Digital Photography Field Guide

Cynthia L. Baron and Daniel Peck

Peachpit Press

Digital Photography Field Guide
Cynthia L. Baron and Daniel Peck

Peachpit Press
1249 Eighth Street
Berkeley, CA 94710
510/524-2178
800/283-9444
510/524-2221 (fax)

Find us on the World Wide Web at: www.peachpit.com
To report errors, please send a note to errata@peachpit.com

Peachpit Press is a division of Pearson Education
Copyright © 2005 by Cynthia L. Baron and Daniel Peck

Editor: Becky Morgan
Production Editor: Lupe Edgar
Copyeditor: Sally Zahner
Compositor: Owen Wolfson
Indexer: FireCrystal Communications
Cover design: Alan Clements, Aren Howell
Interior design: Kim Scott, Owen Wolfson

ISBN 0-321-22054-4

9 8 7 6 5 4 3 2

Printed and bound in the United States of America

Cyndi:
To my dad, the first photographer I knew.

Dan:
To Megan MacCalla, the strongest and
most courageous girl I will ever know.

Acknowledgments

Cyndi:

First, a thanks to Nancy Bernard, for sharing her India experience, to Dan for being the best writing pardner a gal could have, and to Shai, for his infinite support and patience.

For those I know and love who let me take their pictures, a big thanks to my folks and to Rachel, James, and the brand-new Halee Fitzpatrick. A big hug to the Haberman and Cummings families as well, and my beloved aunt Frances.

I can't thank my friends enough as well: the Ullmanns, Fernandopulles, Schneurs, and the well-travelled members of the March 16 group, especially Irene Shea and her buddies at the lake. In addition, a warm thanks and hello to Benny and the rest of the Uganda brigade, who still share so much after all these years.

Becky Morgan, our beloved long-time editor, and the rest of the Peachpit crew, particularly Lupe Edgar and Andrei Pasternak. Thanks for your generosity in letting me put my two cents into the design.

There are many people I can't thank individually, because I didn't know them and their stories when I captured a moment in their lives. To you, thanks for blessing me with your expressive faces and humanity.

Dan:

To Sarah, for everything always.

To Cyndi, my once and forever partner in words and pictures.

To Becky Morgan, our truly beloved editor, Lupe Edgar, Andrei Pasternak, and all at Peachpit for making our work come to life.

Mayn Chaver, Paul Leichter at Tri-State Camera, and Kirsten Odegard for seducing me into the digital world. To my beautiful models: Megan, Kaitlyn, Sheila and Brad MacCalla, Elizabeth Sessa, Sarah Boslaugh, Randy Johnson, Dale Morris, Betty Vornbrock, Billy Cornette, Inbal Samuel, the Pecks of New Jersey, the Boslaughs of Nebraska, Lou Meyer, Dave DiGuardia, Dee and Jim Gunnerson, Phil Levy, Brian Grim, Hank Sapoznik, Naomi Sunshine, Laura Wernick, Harvey and Ilya Varga, Theresa Wiehagen, and Robert Love Taylor.

To David Gahr, Walker Evans, Ansel Adams, Edward S. Curtis, and all my photographic heroes for capturing the world through the lens.

Contents at a Glance

Table of Contents

Chapter 3: Photographing People 29

Chapter 6: Outdoor Places 89

Chapter 7: After You Shoot 113

Using Your Field Guide

Welcome to Painless Shooting

Most digital camera books spend a lot of time introducing you to the technical end of photography. The only problem with this approach is that it's a lot of work for the average casual photographer. You have to memorize which features do what things and how they interact with each other to consistently take successful pictures.

We've taken a different approach. We assume that your goal is to get the best possible shots with the least amount of research and work. So we've arranged this book to make it most valuable when you really need it—with camera in hand, faced with a great photo opportunity.

You'll find suggestions for taking good pictures in the usual situations that everyone experiences—shooting at home, outdoors, at parties, and on the go. Turn to the chapter that covers the situation you and your camera are experiencing, and follow the simple instructions for setting up, framing, and shooting.

Rely on your icons

Digital cameras don't have a single standard design, which may add to the challenge of getting comfortable with them, or with changing brands. Thankfully, manufacturers use icon pictures to label their camera functions. Some of these icons are standards throughout all brands. Others are at least similar from camera to camera. A few are used only by some manufacturers, but are still useful. Once you get to know the icons, you can quickly see how your camera is arranged and what capabilities it has.

Throughout this book, we use these icons to help orient you to various shooting situations. We've tried to cover variations from all the

major brands. When there is more than one way to depict something, we've tried to use icons that frequently appear. Use these icons to quickly prepare for your shot, and to confidently combine features, modes and photography basics to give you the best results.

Icon chart

ICON	NAME	WHAT IT DOES
AUTO	Auto mode	Sets focus and exposure for you: camera default
	Zoom	Focuses the lens at different distances
	Macro	Focuses on subject very close to the camera
	Auto Flash	Determines light level, and flashes if needed: camera default
	No Flash	Turns the flash off
	Fill Flash	Forces the flash to fire, even if there is enough light
	Red eye	Makes flash fire twice
	Flash compensation	Brightens or dims the strength of the flash
	Camera shake	Tells you to use a tripod or flash to avoid blurry pictures
WB	White Balance	Adjusts for color shifts under different types of light
	Fluorescent	White Balance setting to adjust for fluorescent lighting
	Tungsten	White Balance setting to adjust for incandescent lighting
	Overcast	White Balance setting to adjust for dull, cloudy days

ICON	NAME	WHAT IT DOES
	Portrait mode	Focuses close, slightly blurs the background
	Night mode	Takes portrait pictures against a night background
	Snow mode	Maintains good color under very bright conditions
	Panorama mode	Shoots multiple pictures to be merged together with software
	Single shot	Shoots one picture at a time: camera default
	Continuous shot	Shoots multiple pictures in a row
	Exposure bracketing	Shoots multiple pictures at different exposures
	Movie Mode	Shoots several seconds of movie frames
	Exposure compensation	Adjusts for large light contrasts
	Fast shutter	Opens the lens for less time than usual
	Slow shutter	Leaves the lens open for longer than usual
	Self timer	Delays the shot after the shutter button is pressed
	Manual mode	Turns off all automatic camera settings

We've also added one special icon, to indicate tips that help you make your photo more attractive:

| | Art tip | Look for this icon for framing and setup hints |

Don't toss out your manual!

To get the most from this book, you should use your camera's user guide to determine the feature set your camera offers. Once you know that your camera has a feature, and you've used the icon chart above to access it on your camera, you're already halfway to a great picture.

Before You Shoot: Buying Guide

Digital cameras, once a luxury, are now as affordable as film cameras. They're also much more convenient. A digital camera allows you to shoot a picture, view it immediately, transfer it directly to a computer—and from there print it, post it on a Web page, or send it to a friend.

Of course, before you can use a digital camera, you have to buy one. A good place to start is reading *Consumer Reports* to compare the ratings for individual camera models. Online resources, like the Digital Camera Resource Page (www.dcresource.com), will help you compare features as well.

As you hunt for your perfect camera, you'll inevitably find yourself navigating a vast landscape of jargon: *megapixels, digital zoom, resolution*, and *JPEG*, to name a few terms. This chapter will help you learn the lingo and understand what you need to get started.

Megapixels

When you buy a camera, you'll find that pricing is influenced by a camera's *megapixels*. Megapixels measure the number of sensors the camera uses to record the picture. In general, the more megapixels, the better the picture quality, and therefore the larger the print you can make and the more detail (called *resolution*) the camera captures.

Megapixels and Printing

If you expect to print your pictures, you'll want a camera with enough megapixels to produce good prints in your favorite sizes. This chart should help you figure out what resolution will best fit your needs.

Desired print size preferred (inches)	Acceptable	Preferred	Megapixels needed for resolution
2.5 x 3.5 (wallet size)	640 x 480	1024 x 768	Any new digital camera
3.5 x 5 (snapshot)	1024 x 768	1600 x 1200	Any new digital camera
4 x 6 (large snapshot)	1024 x 768	1712 x 1200	2 megapixels
5 x 7	1152 x 864	2048 x 1536	3 megapixels
8 x 10	1600 x 1200	2272 x 1704	4 megapixels*

* 5 megapixels is currently the highest-resolution camera you can buy before moving to high-end professional models.

You'll find that photo services tend to lowball on acceptable resolutions. For example, every photo service will tell you that you can make good 5-by-7-inch prints from a 1600-by-1200-pixel shot. But if you compare the same picture from the same service, printed at 4 by 6 and at 5 by 7, you'll probably notice that the larger print is a little less crisp and color-true. Good, yes; great, no.

Lens and Latency

Megapixels are not the only measure of how good your prints will be. A camera with a high megapixel count but a poor-quality lens might give you worse prints than one with fewer megapixels. As a result, you'll often be most satisfied with a digital camera sold by a company that has experience making good film cameras.

Another reason not to buy your camera based on megapixels alone is a problem called *latency*. Unlike film cameras, which store their images instantaneously, digital cameras can't always record all the megapixels in a shot at once. If you take pictures at high resolution, the camera will freeze while it transfers all the information to your storage medium. Many people prefer a camera that has short latency periods to one that has more megapixels but very slow processing times.

Do's and Don'ts: Don't overbuy

It's easy to be seduced by the notion that bigger is better. A 5-megapixel camera will take better pictures than a 3-megapixel model, right? Not necessarily. A camera with more megapixels will definitely take a better photo when you're using its highest-quality picture formats—TIFF or RAW. (For more about these picture formats, see Chapter 2, "Digital Camera Basics.") However, not all cameras offer even one of these settings as an option. Most of the time, you will probably shoot to produce a 4-by-6-inch standard print, or to view your photos on a computer. If so, counts above 3 megapixels are overkill. Only if you plan to print at sizes larger than 5 by 7 inches do you need to consider a higher-resolution model.

Zoom

The zoom on a camera allows you to make the subject appear closer to the camera without actually moving closer. A 2X zoom makes the subject appear up to twice as close; a 4X zoom, four times as close; and so on. The standard zoom capacity on nonprofessional digital cameras ranges from 2X to 4X.

Zoom types

When the camera adjusts the lens position to get closer to a subject, it is using *optical zoom*. When zooming is done by the camera's electronic circuitry, it's known as *digital zoom*. In simple terms, optical zoom is good; digital zoom, not so good.

Optical zoom is better because it records the image at full resolution, so you get a sharp image at any zoom level. Digital zoom, on the other hand, creates the illusion of zooming by enlarging a portion of the image, just like you could do by using the magnifying lens tool on a computer. Because digital zoom doesn't capture more information, using it results in a lower-resolution image (**Figures 1.1** and **1.2**).

This limitation is especially important if you are going to print the picture, since the photo will be much lower quality. Some inexpensive cameras offer only digital zoom. As this is limiting, you should strongly consider models with at least 2X optical zoom.

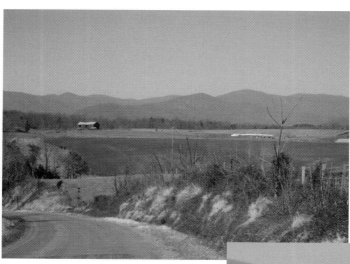

Figure 1.1 At maximum optical zoom, the beautiful Blue Ridge Mountains are distant, but sharply defined.

Figure 1.2 Although digital zoom brings the mountains closer, the details are gone and the loss in quality is noticeable.

Storage Media

Storage media, what the image is recorded and stored on, is the digital camera's version of film—except it can be used over and over.

There are four major types of storage media, all of which come in a variety of storage capacities. Pricing on storage media is about the same from one type to the next for the same capacity.

Most new cameras include media when you buy them, but the included storage device (typically between 16 MB and 64 MB) is more like a starter kit than a really useful item. You'll need to buy another almost immediately, and with a larger capacity.

CompactFlash CompactFlash cards are the most common type of storage device for digital cameras. They come in two flavors: Type I and Type II. There is no

difference between these two types except their thickness—Type II cards are a little chunkier. Practically speaking, that means a Type I card can be used in both Type I and Type II camera slots, but a Type II card can be used only in a Type II camera. These cards have no outstanding drawbacks, and are very stable.

Microdrive Microdrives are the same size as CompactFlash Type II cards. Although they look like flash cards, they are actually very high capacity disks that can hold dozens of high-resolution pictures. The downside: They're not always as resilient as flash cards, and if something goes wrong, you lose a lot more pictures. And because they hold a lot more, they cost more. However, they justify their price by being extremely convenient, especially on long trips.

TIP: Because they can also be used in laptops, microdrives can be a wonderful way to quickly transfer all of your pictures to a computer.

SmartMedia SmartMedia cards are a bit larger than CompactFlash cards, but they are wafer thin. Because they're so slender, SmartMedia cards are also used in some PDAs and small digital cameras. The disadvantage of SmartMedia cards is that the contacts are exposed; so if you get dirt or fingerprints on the contacts, the camera may not be able to read the card.

Do's and Don'ts: Know your flash cards

Be familiar with the different types of storage media. Except for memory sticks, all storage cards look like rectangular wafers (**Figure 1.3**). In most cases, one card type can't be used in a camera designed for a different type. You need to be careful when you buy new storage that it is exactly the type your camera requires. You also must take these differences into account if you decide to buy a second camera, or trade up to a new one. You might find it most cost-effective and convenient to stick with one card type.

Figure 1.3 It's easy to see the differences between memory cards when you can compare their shapes and sizes. From left to right, an MMC/SD card, a SmartMedia card, an MMC/XD card, and a Type II CompactFlash card.

Do's and Don'ts: Buy extra storage

Do buy extra storage media before you need it. It is always better to have
an extra card lying around than to find that you've maxed out your storage
space with one week left to go in a two-week vacation in the mountains.

Memory Stick Memory Sticks are used by a small
number of digital camera manufacturers, most notably
Sony, Konica, and Minolta. In particular, Sony uses
them for all of its digital cameras, as well as most of its
small digital electronic devices. Memory Sticks are
about the size of a stick of gum and, like SmartMedia
cards, are quite thin.

MultiMediaCard (MMC) MMC cards, the newest type
of digital camera storage, are the smallest and sleekest
storage devices yet—about the size of a postage stamp.
They are found in PDAs and cell phones, but are just
beginning to be used in digital cameras. If you have a
Kodak digital camera, or you got your camera as part
of a package deal from Hewlett-Packard, your digital
camera may use them.

You may also come across variations on the MMC
card: Secure Digital (SD or XD). This type is used for
many of the same devices and looks a lot like the MMC
cards. Many highly compact new digital cameras are
being released with one of these variations.

Batteries

There is nothing more frustrating than seeing a remark-
able shot, quickly turning on your camera, and getting
that ugly broken-battery display that says your camera
is out of juice. It can be tempting to wring one last pic-
ture out of a dead battery, but that's a very bad idea. The
image data on your storage card can get permanently
corrupted if the entire picture isn't stored successfully
before the battery dies.

Your first line of defense is to have an extra set of bat-
teries on hand. In most cases, your camera requires a
specific type of battery, and even a special model of
that specific type. Some cameras use standard AA or
even AAA batteries. If so, you might want to invest in
rechargeable versions of these battery types, and a bat-
tery charger.

Optimizing battery life

Unfortunately, even rechargeable batteries don't last forever, but you can take steps to maximize the time between battery replacements.

Always turn your camera off before you try to change the battery. Besides potentially losing pictures on your card, you can lose all of your camera's date and time settings.

Some types of batteries have special needs. Nickel cadmium (NiCad) batteries will expire quicker if you recharge them before they are fully discharged, so you'll want to use them until the camera tells you they're finished. This is not a problem with nickel metal hydride (NiMH) or lithium ion batteries (LIon).

Lithium ion batteries are fairly expensive, so people often expect them to last longer. Unfortunately, a lithium ion battery often stops holding a charge in as little as a year. You can maximize its life by not leaving it in the battery charger after it's been completely recharged. And if you're shooting outdoors in the winter, keep the battery someplace warm. Constant use in the cold wears a battery down quickly.

TIP: Always allow batteries to fully charge once you have started charging. Nothing will run down a rechargeable battery faster than taking a partial charge.

Extras

Depending on your needs and ambitions, you may want to add some items to your digital camera kit. Of the items listed below, only the camera bag is a true necessity. The rest meet particular needs; they will enhance your digital photography experience but they may not be necessities for you.

Camera bag Since you have made a significant investment in your digital camera, it only makes sense to invest a few dollars more to keep it safe and sound. A good camera bag will protect your investment from the elements, not to mention nasty bumps. Bags range in size from small ones that can clip to your belt up to full backpack sizes that can also hold your lunch or even your laptop. Look for a bag with good padding and enough room for batteries, storage cards, helpful Field Guides, and other accessories.

If you have a medium-size bag that holds the camera and its accessories, you may want to get a smaller case as well. One just big enough for the camera and an

extra storage card will help you keep the camera in prime shooting condition even when you don't want to cart all of your camera supplies along (**Figure 1.4**).

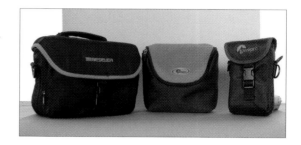

Figure 1.4 A larger bag may be good for traveling, but a smaller one will be more convenient on a hike.

Tripod A tripod provides a stable base for your camera while you're shooting. This enables you to precisely line up a shot, which is especially handy when you create a panoramic shot (see Chapter 5, "Outdoor Places"). If you're shooting in low light and don't want to, or can't use the flash, a tripod will hold the camera steady to give you a clear shot at a slow shutter speed. A tripod, combined with a timer or remote control, will also allow you to be in a picture that you take.

Tripods come in a variety of sizes. A *table tripod* is a small version that's easy to carry around and serves most of the same purposes. A *monopod* is a single leg support that steadies the camera for long exposures. Monopods are great for places like museums, where you might want to shoot a low-light picture without flash.

Cell Phone and PDA Cameras

You've seen the ads. Something extraordinary happens right in front of you, and you want to share it with a friend instantly—and you can, because you have a camera in your cell phone.

Cell phone cameras are unquestionably an exciting technology. But they don't take the place of a digital camera. Because the camera element has to fit inside a phone, you can't focus, zoom, or get a shot with a printable resolution from a cell phone. We don't want to discourage you from owning one, but use it for its instant gratification, not to capture your daughter's piano recital.

All of the advice above also applies to digital camera add-ons for Palm and other PDAs. Such cameras are handy for very limited purposes, but in no way qualify as a replacement for a real digital camera.

Lens cleaner Because a digital camera lens is smaller than its film counterpart, smudges and dirt on the lens will be more noticeable in your photos. If it's not included with your camera, get a lens cleaning kit (liquid and wipes) and a brush to get rid of dirt.

Printer If you plan to make prints of your digital photos at home, you'll need a printer. General-use color inkjet printers, which also print text, will do an acceptable job printing your photos on plain paper. If you use photo paper, which is specially made to create high-quality prints, the results will be better. However, these prints will eventually fade because the ink in office-grade inkjet printers is not meant for photographic use.

For the highest-quality, longest-lasting prints, you should purchase a photo printer. Photo printers create photographs that rival the quality you'd get from a commercial photo developer.

In some cases, you can get a photo printer as part of a bundle when you buy your digital camera. Bundled photo printers will often allow you to connect directly to your camera, or to print directly from your storage card. If you don't own a computer, consider a photo printer with a small LCD screen for previewing your shots before you print. Hewlett-Packard and Canon, for example, are good sources of such printers.

TIP: Never use paper products to wipe your lens. Scratches are forever. To prevent scratches, always brush off dirt before using a lens wipe to remove the smudges.

Buying for Traveling

If you're traveling, you'll run into photo opportunities that you might not experience closer to home. To be prepared, consider taking extra camera accessories, particularly if you won't be in a major city for extended periods of time. You'll certainly want extra storage cards and batteries, lens cleaner, a collapsible tripod, and a nice camera case to put them all in. In addition, if you're traveling abroad, you'll need some particular accessories.

Traveling abroad

If you're going to another country, your battery charger may not work without help. Although most of North and South America runs on 110 volts, the rest of the world primarily runs on 220 or 240 volts. Plug a 110-volt device into a 220-volt power connection, and sparks will really fly.

Some companies design battery chargers for both voltages. If so, the charger will show dual input (100V-240V). Otherwise, you'll need a voltage converter, which you can buy on the Internet and in electronics stores.

You'll also need a plug adapter. Plugs are angled in the Pacific, and rounded in Europe and the Middle East. (**Figure 1.5**) We recommend that you buy a kit, which should include a voltage converter and an assortment of adapters. That way you're covered no matter where your plane touches down.

Figure 1.5 An adapter kit like this one will power you all around the world.

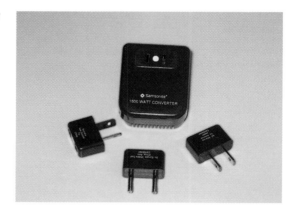

If you are also traveling with a computer, don't count on using your battery charger's voltage converter for it as well. Battery chargers are very low-powered devices. Many computers require a heavy-duty power pack with a grounded plug. Check your computer manufacturer's Web site or your manual for details on what type of converter you'll need.

Travel Precautions

In most cases, caring for your camera while on the road isn't much different from taking care of it at home. But travel, even in a group tour, has an element of adventure and unpredictability. Since bringing home visual keepsakes from a trip is surely one of the reasons you're bringing your digital camera with you, these tips will help you keep your camera and pictures safe and sound on the road.

* Suitcases get lost, and airlines have limited liability for lost luggage, so put the camera in your carry-on bag. Digital cameras don't use film, so they and their pictures can't be damaged by security X-rays.

* Have a charged battery in the camera. In times of heightened security, someone may ask you to prove that your camera is really a camera by shooting a picture with it.

* X-rays can't harm your digital pictures, but magnets certainly can. Don't pack magnetic objects (like compasses) together with your storage cards.

* Check before you shoot. In many cultural or religious buildings, photography isn't allowed. Most of the time, you'll just be politely warned. But you could encounter a more extreme response.

* If you want to take a group picture, ask another tourist, and offer to shoot their group in return. Or ask your tour guide if you have one.

Digital Camera Basics

How a Digital Camera Works

From the outside, film and digital cameras appear pretty much the same. You point a lens at your subject and press a shutter button to take your picture. But inside the camera, there's a world of difference.

In place of film, the digital camera has a small plate that is covered with a grid of light sensors. The sensors are called *pixels* (short for *picture element*). Pixels are the unit of measurement for *resolution*— or digital picture quality. The more sensors, the finer the detail you can record, and the larger the image that you can print. Digital cameras have so many sensors that they are measured in *megapixels*— groups of 1 million pixels at a time.

Each sensor has a filter that lets in red, green, or blue light, like the dyes on color film. Each pixel then stores varying amounts of color for each specific point in the image.

When you press the shutter button, the camera records the amount of each color that each pixel sees. The camera's microprocessor—the small computer "brain" that runs a digital camera—assembles the color information in a digital file and saves the file to a storage device in the camera. You can then transfer that file to a computer or a printer, where the millions of little pieces of red, green, and blue data are reconstructed to create a visual image.

Touring a Typical Digital Camera

Looking at digital cameras is like visiting the zoo. You'll find a daunting variety of sizes and shapes, with an enormous variety of features. But even so, all digital cameras have some elements in common.

Front and top of the camera Camera fronts are very similar from model to model, because they contain most of the standard elements that both film and digital cameras share. The top of the camera varies a little more, but you can usually count on finding the elements pictured in **Figure 2.1**.

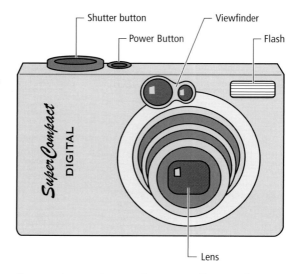

Figure 2.1 Front and top of a digital camera.

Cameras turn on in one of two ways. Cameras that protect the lens by covering it with a *clamshell* case turn on when you slide the clamshell to the side. Cameras without clamshells usually have an on/off button on the top of the camera, which is sometimes combined with a play function to view movies or slide shows.

Camera sides and bottom The sides and bottom of a camera are used for connections and power (**Figure 2.2**). You may find a little door on the bottom or on one side that holds both your batteries and storage. Usually on another side, there's a smaller slot that contains your camera's output socket, where you connect the cable that transfers pictures to your computer or printer or displays them on a TV. Most cameras also have a socket on the bottom to connect a tripod.

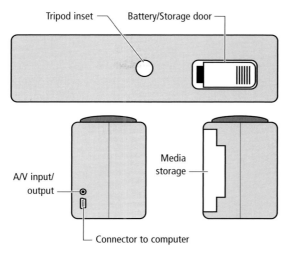

Figure 2.2 Bottom and sides. Batteries and storage can be situated together on the side of the camera or the bottom, or they can occupy different slots.

Back of the camera The camera back is the view you'll see most of the time. Manufacturers design the back in a variety of ways. **Figure 2.3** is a composite of some of the most popular camera layouts.

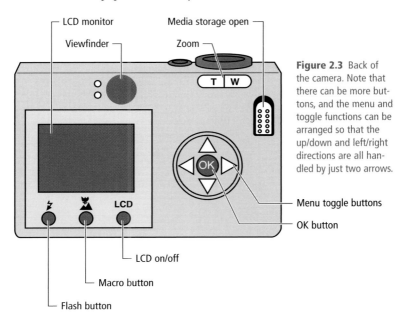

Figure 2.3 Back of the camera. Note that there can be more buttons, and the menu and toggle functions can be arranged so that the up/down and left/right directions are all handled by just two arrows.

Modes and features

The digital functions found on the back of your camera fall into two categories: modes and features.

Modes are digital "recipes" that let you quickly respond to shooting situations. They're named for the situation they are designed for, like Twilight mode, Portrait mode, or Snow mode. *Features* are capabilities—like sound or movie recording—that can be accessed in some, but not necessarily all, modes.

Camera functions can be accessed in one of three ways:

✳ Buttons arranged on the body of the camera. Most cameras have buttons for accessing critical camera features: zoom, flash, the macro setting, and the LCD monitor. Because a lot of information is crammed into a small space, one button can do different things, depending on how many times you press it, or what mode you are in when you press it.

✳ A dial on the body of the camera. Many 35mm film cameras have dials on them for selecting manual exposure settings. Some manufacturers have simply updated this familiar element to add digital modes to the mix.

✳ A menu display on the camera's LCD monitor. Most of the camera features, and the more complicated mode options, are displayed and controlled from the LCD monitor. There's usually a button array that enables you to communicate with the LCD menus. The array often has left and right arrows for changing settings, as well as a Set or OK button.

The menu displays on the LCD are usually a combination of picture icons that represent camera modes you can select, and up/down or left/right scales for increasing or decreasing manual settings.

The Five Basic Camera Functions

Every digital camera, whether it's loaded with features or minimalist, contains five functions you absolutely must master to use it. Some of these are common to film cameras; others are exclusive to digital cameras:

✳ Shutter button

✳ Zoom

* Flash
* LCD monitor
* Quality/resolution settings

Digital cameras take such good pictures in Automatic mode that you can do a lot of shooting without ever using more than these parts of the camera.

Shutter button

The shutter is the single most important function on your camera.

When you're in automatic mode, pressing the shutter down all the way makes the camera calculate the right distance to focus the lens for the object it sees there. It also determines how wide to open the lens to capture the range of light it finds in the picture frame. Then it snaps the picture.

But the shutter button, when held down only halfway, is a powerful tool. Used in this way, the shutter allows you to override the autofocus or autoexposure when you need to do so to get a good picture.

Overriding the autofocus When the subject is not in the center of the frame or there's a very bright object near the center, then the autofocus may not gauge distance correctly (**Figure 2.4**). Temporarily move the camera so that the intended subject is in the center of the frame and hold the shutter button halfway down. Then reframe the shot, and press the button all the way.

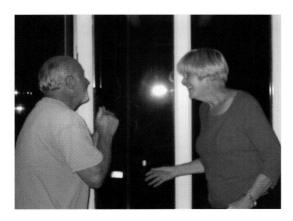

Figure 2.4
The camera's auto-focus was fooled by the reflection of a bright lamp shining on the window in the center of the frame. As result, the dancing couple is blurred.

Overriding the autoexposure Autoexposure gauges the proper amount of light required to get a good shot. If there is a particularly bright or dark area near the center of the frame, it will throw the exposure off. Again, the shutter button will help you compensate. Move the camera so that an area with the correct amount of light is in the center of the frame, and hold the shutter button halfway down. Then reframe the shot, and press the button the rest of the way down (**Figure 2.5**).

It's possible that the situation requires more finesse than simply resetting the autoexposure. Read "Advanced Camera Concepts" later in this chapter for an explanation of some of the manual tools that can help you with these more challenging focus and exposure issues.

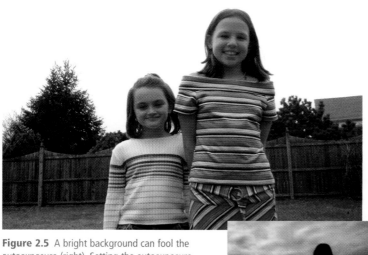

Figure 2.5 A bright background can fool the autoexposure (right). Setting the autoexposure for the foreground delivers the right level of light (above).

Zoom

The zoom control allows you to reframe a shot without moving. This is an incredibly convenient feature that you'll use a lot. You can change from a wide-angle shot to a close-up without moving an inch. Just look through the viewfinder (or LCD display), and push the zoom button to move in or out.

As well as the zoom that works by moving the lens, most digital cameras also have *digital zoom,* but you usually need to turn it on in the function menu. In most cases, you'll be happiest with your results if you leave digital zoom off, and work exclusively with the optical zoom control. In Chapter 3, "Photographing People," and Chapter 4, "Capturing Motion," you'll find hints on using the different types of zoom effectively.

Flash

The flash adds enough light to give the proper exposure when the available light is insufficient to take a good picture. Most cameras automatically use the flash when it's needed. After the camera flashes, there is usually a short delay while the flash recharges.

When the flash is on, the viewfinder displays a steady amber light to indicate that the flash is charged and ready. When the amber light is flashing, either the flash isn't charged, or there isn't enough light to take a picture without it.

If there isn't sufficient light to get a good exposure but you don't want to use a flash, most digital cameras let you turn it off. This strategy poses problems, but in Chapter 5 you'll find suggestions for addressing them.

Digital cameras usually offer some sophisticated flash options besides the simple flash-on or flash-off. Both the "Advanced Camera Concepts" section later in this chapter and Chapter 3 explain how to avoid the red-eye effect, how to add light when shooting against a bright background, and how to fine-tune the flash's brightness.

LCD monitor

The LCD monitor found on digital cameras is a major advance over film cameras, and most of the time it's a better way to frame your shot than using the viewfinder. All cameras have a viewfinder, which is a small lens that you look through to frame your shot. Viewfinders can be deceiving.

Do's and Don'ts: Turn off the LCD when you can

Don't use the display unless you need it. Although the LCD is one of the great boons of the digital camera revolution, it is also a big battery hog. If you are shooting in automatic mode and you don't need any of the camera's special features, you should turn it off. Your batteries will last much longer. This hint is particularly important if you are bringing your camera someplace that has no access to electricity, like to the beach or on a camping trip.

The LCD monitor displays exactly what the camera lens sees. This device gives you an accurate preview of the way you've framed the shot, allowing you to make better judgments before you shoot. After the shot, you can use it to check your results and take a replacement picture if you aren't satisfied.

There is almost always a button next to the LCD monitor that turns it on and off. (By default, the LCD monitor is usually on when you turn the camera on.)

The LCD menu The LCD monitor is where most of the more sophisticated and exciting options on your digital camera are hidden. Usually a Menu button sits next to the LCD monitor. Press it and you have access to most of the digital features—including digital versions of film camera features, like exposure and focus tools, as well as a host of digital-only tools to automate tasks that once required pounds of extra photo equipment and different types of film. Most of the examples in this book require digital menu tools to shoot great pictures.

Quality and resolution

Besides resolution, the element that most affects the quality of an image is something called *compression.* This is a technique for making large image files smaller and therefore easier to transfer to a computer. But the more compressed an image is, the less detail it contains, and the lower the quality. You can shoot an image with lots of megapixels, but if it is very compressed, it might not look as good as a smaller image that's less compressed. Most cameras allow you to select both file size (resolution) and quality (compression) settings.

Selecting the right resolution For most people, it's impractical to take every picture at the highest resolution. The higher the resolution, the larger the file size; the larger the file size, the fewer pictures will fit on a storage card. (See "How many pictures fill a card?" later in this chapter). Storage prices are dropping every day, but massive storage capacity is still expensive.

Sometimes, high resolution is just a space-waster. If you shoot pictures for the Web or email but never print them, you'll have to decrease the picture size to transmit and display them. That adds extra time and work. Why not just shoot at the size you really need in the first place?

Selecting the right quality There is no industry-wide consensus on the terminology for quality settings. A camera may have two quality settings, or as many as four. And the quality settings may vary according to the file size you've chosen. Some camera companies, for example, offer very high compression on the smallest image size, which is used for email and the Internet, but not on larger image files that will probably be printed.

Even when two manufacturers use similar names to describe their quality levels, the actual files may not be the same sizes. In fact, various cameras from the same manufacturer can differ, depending on when the camera was released and its megapixel count.

Do's and Don'ts: Save default presets

Save yourself a lot of work by having the camera remember your last settings. Few things are more irritating than making several camera-setting changes, getting distracted by something, and then having your camera turn itself off—requiring you to step through all those menus again. Most cameras offer you the option either to reset the options to their original (default) settings when you turn the camera off or to keep your chosen settings when you turn it off.

On the whole, you should select your camera's highest quality range for photos that you'll print at large sizes, a medium quality range for small snapshots, and a low quality setting for images sent via email or posted on a Web site (**Figures 2.6** and **2.7**).

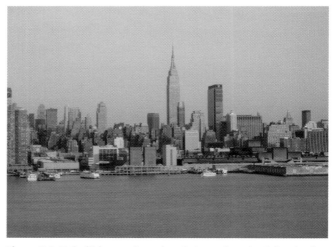

Figure 2.6 At the highest quality and resolution settings, the skyline details are sharp. This resolution and quality combination will give you a great 4-by-6-inch print, as well as a nice 5 by 7 or even an 8 by 10.

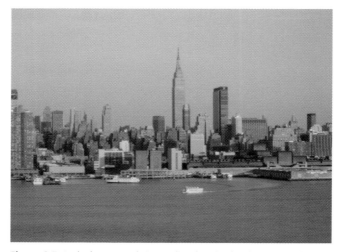

Figure 2.7 At the lowest resolution and quality, the details are markedly less clear. Notice the boat on the river. This settings combination is acceptable only for images intended for email or the Web.

How many pictures fill a card?

This question is on everyone's lips, and it's a tricky one. The quality and size of the image you've chosen will determine the answer, as will the make and model of your camera. In all cameras, higher quality and resolution make for fewer images on a card.

Because the quality standards and the image sizes you are able to select vary by manufacturer, any capacity chart can only estimate the number of images your camera's storage device will hold. This chart provides sample storage capacities for different image sizes on a 16 MB card. When you use it to figure out how many cards you need, begin by assuming that the cards will hold the smaller number of images, until you get a sense of your camera's unique abilities.

IMAGE RESOLUTION (PIXELS)	IMAGE QUALITY	NUMBER OF IMAGES ON 16 MB CARD
640 x 480	lowest	140–240
	low	80–99
	medium	45–55
	highest	29–35
1024 x 768	low	40–60
	medium	20–30
	highest	12–15
1280 x 960	low	35–45
	medium	20–24
	highest	10–13
1600 x 1200	low	35–50
	medium	24–30
	highest	12–16
2048 x 1536	low	16–20
	medium	6–10
	highest	4–6
2272 x 1704	low	12–18
	medium	4–8
	highest	0–3

Note that most cameras have a function that keeps track of how much space you have remaining on the camera's storage card and displays the number of remaining shots at the camera's current settings.

Changing settings In most cases, you select your file size and your quality setting in the same portion of your LCD menu. This menu also might let you change the type of file you make (see "Image Types," below). If so, it will save information about quality and resolution separately for each image type you select. In most, but not all, cameras, once you set resolution and quality, these settings remain even when you turn the camera off.

Image Types

With digital photography, you don't have to decide between slide and print film, or daylight film and low-light film, as you do with a film camera. But your digital camera might be able to shoot and save pictures in more than one file type. Like film types, file types are designed for special purposes.

There are three file types that digital cameras might offer you: JPEG, TIFF, and RAW. All cameras can save in JPEG format, which is always the camera's default factory setting. If your camera doesn't allow you to change file formats, then it is shooting and saving JPEGs.

Some cameras also offer a file format that maintains more information and much better image quality than JPEGs. If yours does, that format will be either TIFF or RAW. (No cameras currently offer all three types.) Either TIFF or RAW is much preferred if you plan to transfer your images from the camera to your computer and edit them, or if you are shooting at a higher resolution and quality in order to enlarge your prints.

TIP: You can mix file types and sizes on the same storage card. So you can use different formats for different pictures just by changing the settings.

RAW and TIFF file formats are only worth using if you have a computer and software that can recognize them. They use up considerably more storage room than JPEGs, and many digital printing services don't accept them for printing because they can't read them. However, if you are handy with image-editing software, you can edit images in these file formats, then save copies in JPEG format to print them using a printing service.

Advanced Camera Concepts

The Automatic mode on most digital cameras will give you good, and often great, quality pictures, especially under ideal conditions. Sometimes, though, conditions are more challenging, like night shots or shooting under fluorescent lights. If so, you'll need to explore

some of your camera's more advanced capabilities. In this book, you'll find solutions for several of these types of situations. To understand and experiment successfully with these possibilities, it helps to understand a few additional camera features.

Shutter speed

On a film camera, a physical shutter inside the camera closes and opens the lens. How long that process takes is called the *shutter speed*. On a digital camera, shutter speed refers to the length of time it takes the pixel sensors take to capture the image. The technology may be different, but the concept is the same. Fast shutter speeds allow you to "freeze-frame" action. Slow shutter speeds will capture motion blur and allow you to capture more image information in lower-light situations. Shutter speeds can sometimes be set with a special camera mode (see Chapter 4, "Capturing Motion," for more about shutter-speed modes). They can also be fine-tuned in a manual mode.

Exposure compensation

To get the convenience of your camera's autoexposure plus a degree of control, some cameras offer *exposure compensation*. With this feature, you can set the autoexposure to be slightly lighter or darker than the camera's initial reading, to tone down glare in very bright sunlight or to enhance highlights in deep shade.

Most exposure compensation controls measure the compensation as positive and negative decimal numbers (**Figure 2.8**). Setting a positive number will make the picture brighter and a negative number will make it darker. Several situations covered in Chapters 5 and 6 will help you with these challenging focus and exposure scenarios.

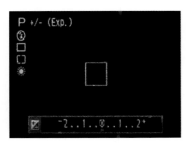

Figure 2.8 Exposure compensation is available only in a manual mode. This display allows you to increase or decrease the exposure by moving the slider up or down.

Flash correction

If you need to use the flash but find that the resulting picture is too light, too dark, or just too glaring, you'll be happy if your camera offers a flash-correction feature. Usually found as an option in one of the LCD menus, it offers a sliding brightness scale so you can fine-tune how much light to use.

White balance

If you're shooting in certain kinds of lighting, such as indoors with artificial light, you can wind up with odd-looking results. Because artificial light has different amounts of particular colors than natural light, a shot may be too red or too green (**Figure 2.9**). Digital cameras have a marvelous feature called *white balance* (or often, WB) that prevents this problem entirely.

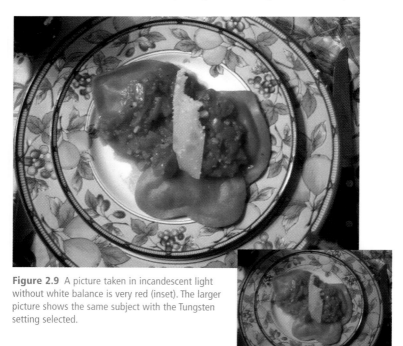

Figure 2.9 A picture taken in incandescent light without white balance is very red (inset). The larger picture shows the same subject with the Tungsten setting selected.

The White Balance setting (**Figure 2.10**) can be set to correct for:

* Incandescent light
* Fluorescent light
* Overcast days
* Full noontime sun

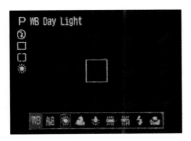

Figure 2.10 A White Balance display offers several icons representing different types of indoor and outdoor lighting.

Most cameras also have an automatic setting to determine the best white balance for a shot, but complicated light combinations (like natural light from windows combined with indoor lamps) can confuse the camera. In addition, every camera handles white balance a bit differently, so two different models can make different decisions in automatic mode. Experimentation is key.

Photographing People

Setting Up for Great Portraits

Although beautiful settings bring out the shutterbug in us all, we most frequently take pictures of people. We want to capture our beloved family, our friends, or the fascinating strangers we meet on trips. Yet few of our pictures do our subjects justice. That's why people go to professional photographers for their portraits. But by using some professional tips, you can improve the chances that the images you shoot will flatter your subjects and help them communicate who they are.

Find the good side

Faces are rarely symmetrical. One side almost always photographs better than the other. Since the differences between sides become more prominent as people age, you'll often get a better shot of adults if they turn their head slightly while looking at the camera (**Figure 3.1**).

Figure 3.1 Even a slightly turned head can enhance a portrait.

Experiment with distances

A close-up portrait is a standard solution for formal shots, but don't limit yourself. Position the person's head slightly off-center in the frame, and pull back far enough to see the neck and a bit of shoulders for a flattering pose (**Figure 3.2**).

Figure 3.2 This portrait commands attention. The subject's upper body nicely frames his face.

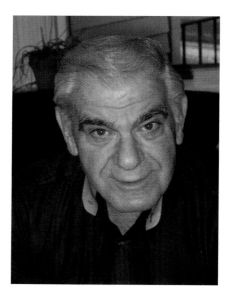

Pulling back even further, and including the subject's upper body, will often make a person look more graceful, and give you a shot with more balance (**Figure 3.3**). Since you're not as close to the subject, shooting at a slight distance will also make details like fine lines less prominent.

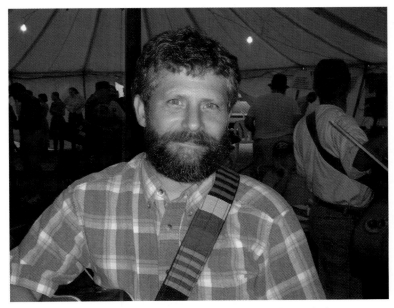

Figure 3.3 Including the upper body will often give you a nicer photo and a better story.

Rotate the camera

It's easy to get into a rut and always shoot with the camera held horizontally. But with a digital camera, it's just as easy to shoot with the camera turned 90 degrees, because you can see your shot in the LCD. When shooting a picture with a single subject, you'll often get a better-framed picture when you shoot vertically.

Because on most cameras the shutter button sits on the top right, it will easier to press the button if you turn the camera clockwise (so that the button is at the bottom). This will give you a steadier shot than if you reach over the top to press the button.

Portrait tactics

Most adults tense up in front of a camera. The secret to getting a good shot is to overcome that tension. Your most effective tactics are humor and ambush.

Let the subject get used to being in front of the camera by not shooting immediately. Telling them a joke or even making a funny noise will get them to relax momentarily. Take that opportunity to get a shot with a more natural expression (**Figure 3.4**).

The ambush technique works beautifully on people who are camera shy, or who say that they don't take good photographs. Frame the subject when they don't see you. Wait for them to turn and face the camera and get the shot in the second before they have the chance to freeze up (**Figure 3.5**).

Figure 3.4
You can always tell the difference between a forced and a natural smile. As this shot shows, natural is always better.

Figure 3.5
Catching the subject off-guard makes for a portrait full of personality.

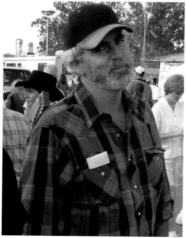

Watch the background

One of the secrets to composing a good photo is patience. Before you push the shutter, look through the viewfinder. There may be subtle distracting elements or ones that will look positively silly (**Figure 3.6**). By moving the camera or subject slightly, you can eliminate the unwanted effect.

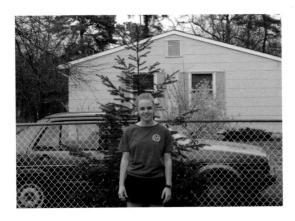

Figure 3.6 This badly chosen background tree makes the subject look like she's wearing antlers.

If there's no way to avoid capturing some terribly distracting element, perhaps you can make it less obvious. If your digital camera has a Portrait mode, switch to it. When you shoot, your subject will remain sharp and clear while the background fades discreetly away.

Flattering Close-Ups

A good close-up is a joyful experience. People love pictures that make them look attractive and happy. But close-ups also emphasize the things that people like least about themselves: wrinkles, bad skin, their nose, their chin, that mole on the side. It can be a puzzle, when you've set up for what you think is the perfect shot, to see an image that doesn't live up to your expectations.

The two most frequent problems with close-ups are lighting and distance. To eliminate them:

Control the flash

The flash will save you from fuzzy, dark, bad-color shots, but it can create its own problems. In a close-up, it often casts too much light and washes out your subject's features.

 Flash compensation Many cameras allow you to adjust the strength of the flash. This feature is called *flash compensation*. If you're not sure that your camera has this function, look carefully at the icons, either in the list of flash options, or in the section of the camera's settings where you set white balance (see "Shooting Indoors" later in the chapter).

When you locate flash compensation on your LCD, you'll see a bar, with a marker that you move into the positive or negative range, starting with the normal setting in the center (**Figure 3.7**).

Figure 3.7 The flash compensation can be increased or decreased for different needs.

-2 . . 1 . . 0 . . 1 . . 2+

To figure out how much flash you really need, try sliding up or down the scale, shooting tests at different exposure compensations (**Figure 3.8**). (The technical term for this is *bracketing*.) When you find a level that casts the right amount of light on the face without bleaching it out, set that amount as your default for the current shooting session.

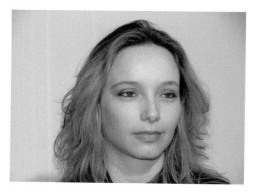

Figure 3.8 This series of portraits shows how a little difference in lighting can make a big difference in portrait quality.

Using Fill Flash instead of flash compensation Flash compensation does a good job of adjusting light, but if your camera doesn't have this option, you can replace the regular flash with the Fill Flash setting, which almost all cameras do have. It doesn't provide as much control, but it's usually less harsh than a regular flash. For more information about Fill Flash, see "Compensate for Low Light" later in this chapter.

Know where to stand

Portraits taken close up with a wide-angle zoom setting are seldom flattering. They stretch out the facial features, making the subject look heavier. They also tend to distort the features that are closest to the camera, creating an unattractive fish-eye-lens effect that usually makes noses look more like beaks. Stepping back from the subject and using the zoom to frame the shots will usually give you a better result (**Figure 3.9**).

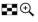

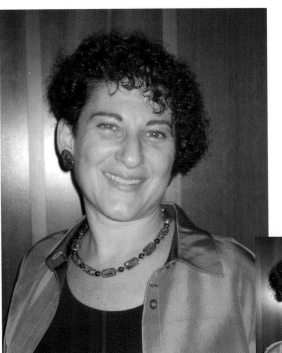

Figure 3.9 Stand back from your subject and use the zoom lens to frame a closer picture. This subject looks distorted, and entirely different, in a wide-angle shot (inset).

Do's and Don'ts: Don't cut their heads off

Do use the LCD viewer to frame your pictures. Unless you've purchased an expensive, professional-level single lens reflex (SLR) camera, you are working with a camera with two lenses. The first lens is the one that actually takes the picture. The second is above it, in the viewfinder.

The problem with a double-lens system is that you are not seeing exactly what the camera sees. This slight offset between the views is called *parallax*. For most shots the difference is too small to be a problem. But for close-ups, you could wind up with the classic cut-off head effect (**Figure 3.10**).

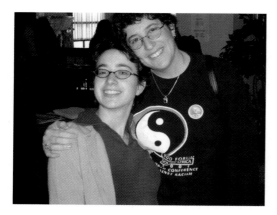

Figure 3.10
This shot looked perfect in the viewfinder but was actually framed too low.

Fortunately, digital cameras have the LCD screen viewer, which gets its image from the main lens. However, in bright sunlight or when you're conserving battery life, you have to rely on the viewfinder. When you can't use the LCD to set up your shot, allow extra room around the subject to avoid cutting off important bits. Some cameras have marks visible through the viewfinder that help you determine what will be in the shot.

Avoiding Red-Eye

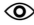

One of the most common problems when using a flash is the dreaded red-eye effect. This occurs when the flash reflects off the iris of the eye, creating a demonic effect (**Figure 3.11**). If you're using the flash, check your camera's LCD display right after the first shot to see if your subject has red eyes. An immediate check will save you many unattractive pictures.

TIP: Red-eye is more prevalent with light-colored eyes than dark ones.

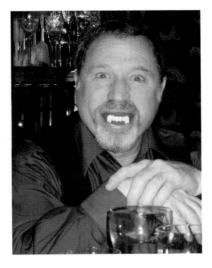

Figure 3.11 The gentlest person turns into a monster when red-eye strikes.

Most cameras have a red-eye reduction setting that you can toggle to by pressing the flash button. This fires the flash twice, once before the shot and again when the image is recorded. The first flash makes the iris of the eye open up so that the second flash is not reflected and the eyes look normal. Before you reshoot, remind the subject that there will be two flashes so they don't move before the picture is actually taken.

Sometimes red-eye can be avoided without the red-eye reduction function by shooting at a slight angle rather than head-on (**Figure 3.12**). This method is preferable for children and pets. They often don't like one flash, let alone two.

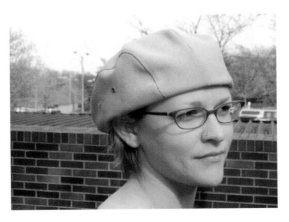

Figure 3.12 Shooting at a slight angle eliminates the red-eye effect.

Photographing Young Children

Pictures of children capture important stages in their growth, so don't miss the opportunity to get pictures of kids in their in team uniforms or party costumes. Although basic portraits are always nice, shots of children posed with a first bicycle, a new pet, or the Grand Canyon in the background will tell a far more compelling visual story (**Figure 3.13**).

Most kids are thrilled to be photographed, so they make very willing subjects. But they are also easily distracted and have boundless energy. Keeping them involved the whole time you're shooting can be a challenge.

Choose a time when you're mostly likely to have their interest and cooperation. If you are planning to shoot a family gathering, do it early on. Kids have a knack for getting dirty and wrinkled (not to mention tired and cranky), particularly after a meal.

Figure 3.13 How can you pass up a child's first Halloween?

Candid child shots

Taking pictures when your child is involved in an activity is a great way to capture candid, informal photos. Some of the best pictures are when children are interacting with each other, not with adults. A game of softball or a storytelling session can offer good opportunities to catch them being their lovable, unique selves (**Figure 3.14**).

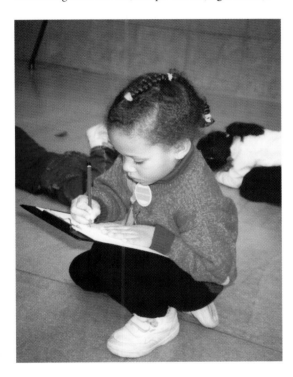

Figure 3.14 Children are natural subjects. This child was busy drawing, and was completely unaware that she was being photographed.

Digital cameras do, however, present one particular challenge when you're trying to take candid shots of children: an irritating problem called *shutter latency*. This occurs when you press the shutter button but the camera doesn't immediately take the picture. This lag between action and shot happens especially when you're using an inexpensive point-and-shoot model at high-resolution settings. The most frustrating thing is that it can make you miss the perfect moment

To overcome this limitation, try to anticipate action so you can press the button a moment before the one you want to capture. Your camera may have the option to

take several shots in a row (**Figure 3.15**). This is called continuous or sequential shooting, and it's excellent for child activities. You can often find this as a Drive menu option or, at lower resolution, as a movie option. See Chapter 4, "Capturing Motion," for more details.

Figure 3.15 When children are your subject, continuous shooting ups the chance that you'll have a keeper.

Do's and Don'ts: Use good "photo etiquette"

When taking portraits, especially of strangers, respect your potential subject (**Figure 3.16**). Never take a photo of someone without asking permission. If they say no, honor their request and look elsewhere for a subject.

When shooting when there are others around (at a wedding, for example), be considerate and don't block the view of others more than necessary. If you must get in the way, get your shots as quickly as possible. Don't stand there and review your shots. Move off to the side, check your work, and then move back to take more pictures. See Chapter 4, "Capturing Motion," for more on this.

Figure 3.16 This man in Portugal rewarded our politeness with his perfect, graceful poise.

Setting up a formal portrait

Although you can get some terrific pictures on the spur of the moment, sometimes you want to exercise some control, particularly for holiday cards or photos you'll give as presents. With children, the more you can test and arrange before you shoot, the better the experience will be for all.

Do's and Don'ts: Line up help for the shoot

Don't try to get the shot on your own. Good child portraits shouldn't be one-person affairs. There are many ways that others can help you:

* Enlist an adult or older child to stand in for the subject. Young children have no patience for being posed.

* Ask a patient adult to keep the child occupied while you work. Like the pros, you should concentrate on your shooting, not on keeping Heather in her chair.

* Make the shoot a group event. Shoot the child alone, then add in other family members for visual variety, and good kid distraction.

Select a background First, find a good, nondistracting background. Avoid backgrounds that are much brighter than the foreground where your subject will be. Bright backgrounds can make the camera set the autoexposure incorrectly and put the faces in shadow (**Figure 3.17**).

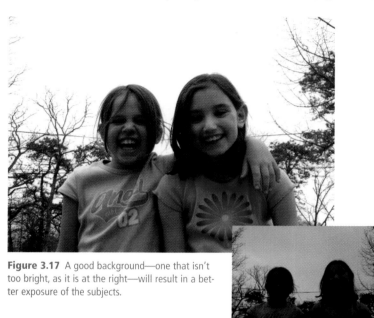

Figure 3.17 A good background—one that isn't too bright, as it is at the right—will result in a better exposure of the subjects.

Take test shots

Shoot several tests and review them on the camera's display. Each setting you can determine in advance shortens the time your child will have to sit patiently. If you have a tripod, testing will be easier, and you won't have to remember exactly where you stood and how you framed and zoomed.

What should you test? Everything. These tips will help you be organized:

* Shoot just the background to see how it looks when framed.
* Have your test model stand, sit, and face in different directions.
* Experiment with vertical and horizontal shots.
* Shoot from different positions and zoom settings.
* If you'll need a flash, bracket for flash compensation so you know what settings to use.

Making Memorable Group Photos

From sixth-grade mementos to Little League baseball teams, weddings, and reunions, you always want a picture that includes the whole gang. Years later, these photos will be pulled out as prime nostalgia fodder, or to help you remember exactly what Billy Burke looked like before he shaved his moustache and cut his hair. To make these photos work—for now to capture memories, for later to resurrect them—you'll find that planning your shot can make all the difference.

Most amateur photographers allow their group subjects to arrange themselves. Some people rush for prime spots, and others look for hidey-holes. Gently but firmly, take charge. You have several goals in a group shot, in order of importance:

1. No one should be hidden.

2. Faces should be large and clear.

3. People should be easy to identify later.

4. The photo itself should be well composed (**Figure 3.18**).

Figure 3.18 Even a basic "line-up" looks better with variety and a good setting.

Watch for shadows

 If you're shooting outdoors, there can be strong differences between light and shadow areas. Before you commit to a locale and an arrangement, check to see that no one is in deep shadow. If they are, refer to "Compensate for low light" later in this chapter.

Create visual levels

 Rearrange people so you can see everyone. The simplest, although perhaps not the most creative, way to do that is to move shorter people into the front row, and taller ones to the back.

If you don't have a lot of difference in heights, create it. Standing people on a well-lit set of stairs will equalize heights. If there are no stairs, a line of chairs will serve the same purpose. (Chairs allow you to put tall people right in front.) Combining several levels is the best of all, because you'll get the best composition options that way (**Figure 3.19**).

Figure 3.19 This intriguing arrangement of Indian bricklayers shows how variations in distance and position can make a group shot compelling and artistic.

Get as close as you can

Varying levels help in another way: They allow you to move individuals and their faces closer, so you can fit more people inside the picture frame comfortably. That means more faces, at a more recognizable size. Zooming in as close as possible also helps you eliminate background elements that might be perfectly nice objects, but add nothing to the memento (**Figure 3.20**).

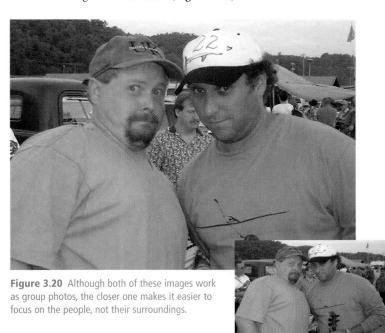

Figure 3.20 Although both of these images work as group photos, the closer one makes it easier to focus on the people, not their surroundings.

Do's and Don'ts: Shoot group variations

Don't neglect the opportunity to take photos of different subgroups. After taking a photo of the entire family, you can get just the grandparents and grandkids, for example. Working with smaller numbers allows you the freedom to arrange people by affinity groups, which will jog people's memories later ("Now whose side of the family was that guy from?").

Make sure to do a quick review of your photos before letting everyone go. It's usually difficult to gather the troops for a second round if you've erred the first time.

Choose your subject

 Are you taking this picture to help people remember each other, or so they can remember the setting? If your group is small, you can do both, by pulling back a little to show more scenery, or by shooting a vertical portrait to capture that snow-covered mountain in the background. Otherwise, make a choice, or shoot your photo twice—zoomed in and zoomed out. Don't expect one photo to serve both purposes. Digital photos do not enlarge as well as film does. Once you've pulled back to capture that great scenery, details of the people's faces are permanently lost (**Figure 3.21**).

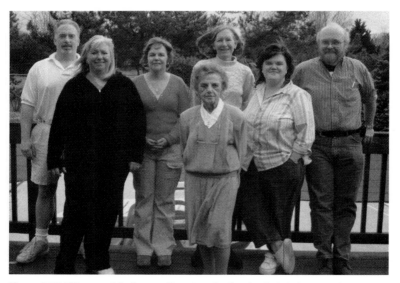

Figure 3.21 This was originally a small portion of a shot that included scenery. As you can see, this enlargement is not sharp and clear the way a film enlargement can be.

Getting Yourself in the Picture

It's fun to be the designated photographer. But if you are always the person taking the pictures, someone important will be MIA: you.

Of course, you can always ask someone else to take over. But the person you ask may not know how to use your camera, or may not know how you want the picture framed. Ideally, you want to be in both places: behind the camera and in front of it. Your digital camera's self-timer or remote function will help you do just that.

Setting up

You'll need a tripod, or a well-positioned stable surface. Focus, frame the picture, and fix the position of your camera. If you're with another person (or a group of people), make sure that you've left enough room for yourself in the shot so you won't be cut off. If you're taking a solo self-portrait, make sure that you have some-thing in the frame that will act as a placeholder to guarantee that you won't be left out of the shot.

Using the self-timer

Some cameras come with a remote control. Finish your setup, position yourself, and then just press the button on the remote to take the picture (**Figure 3.22**).

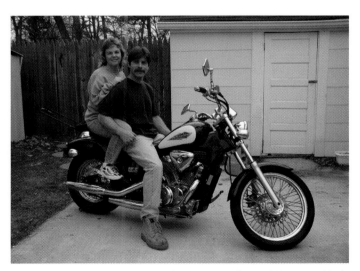

Figure 3.22 Using a remote, you can shoot a portrait that might be impossible if you had to hurry to get into the picture.

Remotes are very useful, but most point-and-shoot cameras have a self-timer function instead. It's usually available in all shooting modes. Once you've set up, you go to your menu, select the mode or function, press the shutter button, and move into the shot.

High-end cameras offer a choice of delay times. Less-expensive cameras have just one delay, usually 10 seconds. Let anyone else in the picture know how long the delay will be, so they will hold their position (and smile) until the shot is taken (**Figure 3.25**).

Figure 3.23 Everyone in the picture should be prepared for the photographer to join the fun.

Do's and Don'ts: Using self-portrait mode

Shoot your own close-up. Some camera models have a special mode called self-portrait. When you select it, it automatically locks on the object it sees at the expected distance from hand to face (hopefully, you), and sets the zoom level to prevent you from being distorted (see "Flattering Close-Ups," earlier in this chapter). To use this mode, select it, point the lens toward the spot where you'll be posing, and push the shutter button. Since you can't see how the shot is framed when you take it, you will probably want to take several shots from different angles to get make sure you get a good one (**Figure 3.24**). Because this setting is meant for a very specific situation, don't use it for anything other than a close-up. You'll lose any details in the background.

Figure 3.24
Although you can use the self-portrait mode for a formal shot, it's really best for a fast and fun close-up.

Shooting Indoors

In auto mode, digital cameras measure the available light to give you an optimal amount of color brightness. Often this setting is all you need. But if you're shooting indoors with the lights on, you can wind up with odd-looking results. Unlike natural light, artificial light has different amounts of color, so a shot may wind up looking too red or green. This is especially important when you're taking pictures of people, since the color problems make for unflattering portraits.

Digital cameras have a marvelous feature called *white balance* to prevent this problem. It allows you to manually adjust the color of a shot, or to use one of several presets, depending on the type of light you are shooting in.

WB

TIP: Every camera handles white balance a bit differently, so you'll need to experiment a little first to get a sense of what works best for you.

Incandescent light

When shooting photos in a room lit by regular (incandescent) light bulbs, your pictures can take on a red cast.

To avoid this problem, select White Balance. Look for the icon in the LCD display that looks like a standard light bulb. This is called either Incandescent or Tungsten. If the picture looks more natural, especially the skin tones, use that setting for your photos. If you're not sure, take some shots with the white balance set to Automatic and Incandescent to make sure you get what you're looking for (**Figure 3.25**).

Figure 3.25 The dominant red in this picture (inset) affects white areas and skin tones. Selecting the Tungsten option cleans up the red shift considerably.

Fluorescent light

Fluorescent light causes colors in a picture to shift to green. To avoid this problem, select White Balance. Look for the icon in the LCD display that looks like a lit fluorescent bulb. Your camera may have more than one fluorescent option, because there are different types of fluorescent light bulbs that create different color effects. You may have to try both types and compare them with the Automatic setting (**Figure 3.26**).

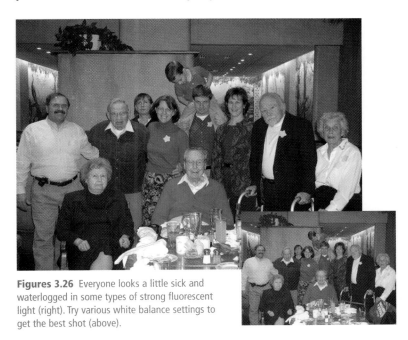

Figures 3.26 Everyone looks a little sick and waterlogged in some types of strong fluorescent light (right). Try various white balance settings to get the best shot (above).

White balance with a flash

If you're using a flash to shoot, you shouldn't have to worry about color correction—the flash will provide properly balanced light. But the flash may not cover the entire subject. If so, the background or the edges of the picture may show a color imbalance (**Figure 3.27**). In that case, use both the flash and white balance to the correct incandescent or fluorescent setting for your room.

TIP: Some cameras automatically turn off white balance when the flash is used.

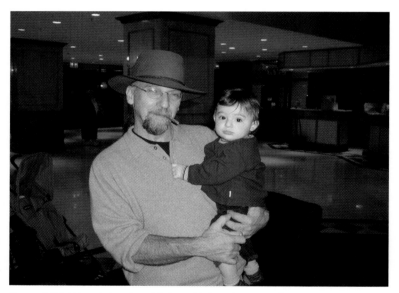

Figure 3.27 Although there is well-balanced light in the center of the picture, the flash isn't strong enough to reach the picture's edges.

Compensate for Low Light

When taking a photo where the subject is partly in the shadows, such as under a tree or in front of a strong light, you will often notice that details in the darker areas are lost. Using a regular flash setting might throw more light than you want, washing out the subject and making the shot look less natural.

You can use the Fill Flash (or "flash on") setting to throw just a bit more light on the subject, bringing out the darker areas without overwhelming the lighter ones or creating deep facial shadows (**Figure 3.28**). Unlike the automatic flash setting, which prevents the flash from firing when the camera sees there's sufficient light for the shot, this setting will flash no matter what, adding necessary light.

Figure 3.28 The smaller picture's background is much brighter than the foreground, so the face is almost completely obscured. Using Fill Flash, you can bring your subject back into the picture without losing the bright background.

Fill Flash can be useful for portraits even when there are no deep shadows. You can use this setting, especially for close-ups, to create a nice even light. As always, experiment with it, taking shots with and without, to get the best results.

Shooting Outdoors at Night

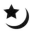

When you're shooting outdoors at night, the flash will illuminate the subject but may not capture anything else because the background is out of the flash's range.

If you want to capture a portion of the background, some cameras offer Night Scene mode. With this setting, the flash fires, but the shutter stays open longer to capture the darker areas of the shot without overexposing the people (**Figure 3.29**).

TIP: If you're using the Night Scene mode, you'll get the best results if you use a tripod to steady the camera. Otherwise, lights in the background can blur and streak.

To use this feature, first select Night Scene. Set up your shot, focusing on the subject in the foreground. When you take the picture, the background will show more detail without making the subject look like a ghost.

Figure 3.35 The flash works only for a very short distance. It won't illuminate a background. By opening the shutter, the background has more time to be captured by the camera.

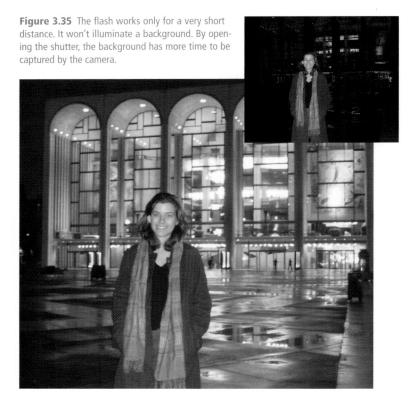

Do's and Don'ts: Dramatic silhouettes

Take advantage of Night Scene mode. Sometimes you really want to create
a silhouette of a person. This is easy to do in daylight by just letting your
autoexposure gauge a bright area and not using the Fill Flash. But if you
want a dramatic silhouette, set up your tripod and frame your scene. Select
the Night Scene mode and turn the flash off. You'll have a sharply silhouetted
outline and a dark and dramatic backdrop (**Figure 3.30**).

Figure 3.30 Turn off the flash and set the autoexposure to the background for a
good silhouette.

CHAPTER 4

Capturing Motion

Getting good pictures of people and things in motion presents different challenges than photographing posed, cooperative people or stationary things. No matter what type of action or event you want to capture, you'll get your best pictures by being prepared and by knowing how to use of some helpful camera modes and features.

Preparing for Movement

You can improve your hit rate of great shots by being prepared, both technically and creatively:

* Make sure your batteries are charged and you have an empty memory card (or two) with a large storage capacity—you probably won't have time to edit your shots until the event is over.

* One of the secrets of action shooting is to take lots of pictures. When the action begins, start shooting and keep at it until there's a lull. The best sports photo is a perfectly timed shot culled from a series of almosts (**Figure 4.1**).

* Many special events take place at night, or in subdued lighting. People in motion are particularly bad subjects in dim light: If they aren't blurred, they're usually too dark. But using a flash when you photograph can be impolite and distracting in this kind of situation. Instead, bring a tripod so you can shoot with the flash off.

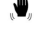

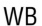

WB

* Set and save as many camera functions in advance as you can. In particular, select your resolution and quality settings, and determine the right white balance setting for your background light.

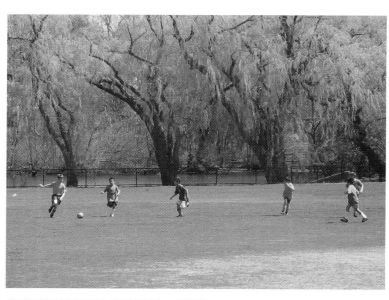

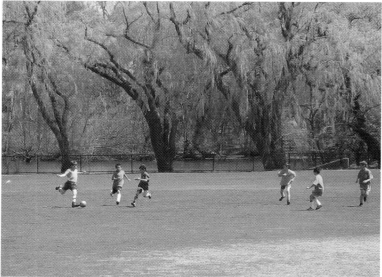

Figure 4.1 These two pictures were photographed a moment apart. The second shot captures the height of the action.

Action at Special Events

Like family portraits, photos of formal ceremonies such as weddings are treasured remembrances. But getting the right shots takes planning. The most memorable pictures of a special event won't be the posed ones. They'll be captured motion—like of the bride walking down the aisle. The special nature of a formal ceremony prevents you from stopping the action to set up your shots. Here are ways to make time stand still without blocking its way.

Knowing your role

If you are the designated photo honcho, do take those formal portraits discussed in Chapter 3, "Photographing People." But if a professional photographer has been hired, stay out of the way. Pros won't thank you for using your flash while they're setting up lighting. And unless you shoulder the pro aside (a bad idea), you'll end up shooting when people aren't prepared, and from the side of the action (**Figure 4.2**).

Figure 4.2 All of the subjects here are expecting to pose for the professional photographer, not for the unofficial family shooter. As a result, they are looking away from the camera, and not all of them have expressions they'll want to remember.

If you'll be shooting pictures as a formal event or ceremony takes place, check out possible vantage points in advance. Stake out a position that lets you capture the action without becoming a part of it (**Figure 4.3**).

Figure 4.3 This unconventional wedding picture doesn't show the bride's and groom's faces, but it does capture the beauty and solemn tone of the setting without intruding.

Telling a story

You'll have more fun, and probably take more memorable pictures, if you think of the ceremony itself as the centerpiece of a much larger scene.

Look for pictures that help to tell a story. Shoot preparations for the event (**Figure 4.4**), and the fun at the reception afterwards. You and your camera will be most appreciated if you concentrate on candids—those hilarious and tender moments that can't be planned.

Search out people who are central to the event, or who are animated and happy. Once you have someone who is worth noticing, act like a paparazzi and follow them until you get the shot you want.

Figure 4.4 Paying attention to pre-ceremony details guarantees unique results.

Action from the Stands

You can't always get up close to an event, but don't think that means you should leave your camera at home. You may not be positioned for close-ups, but you can still get memorable spectator shots.

Visualizing the action

It helps to know an event's schedule (When will the procession take place? Where will the grads enter?), or to understand the sport you're shooting. You'll take the best shots by figuring out not just where the action is, but where it will continue (**Figure 4.5**). For example, if you can plan a shot of a batter that includes the infield, you might capture not just the swing of the bat, but the rest of the play as well.

Figure 4.5 If you anticipate the action on both sides of the net, you'll keep the camera's eye on the ball.

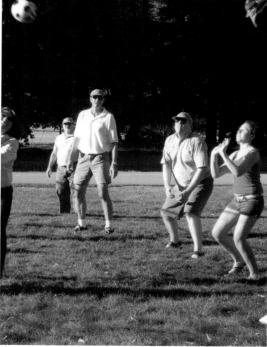

Using digital zoom

When you're shooting at a distance from the action and your camera's zoom isn't powerful enough, it's hard to know if you're capturing what you intend. If you need close-ups and can't afford to be picky, try the digital zoom. A lower-resolution picture is better than no picture at all (**Figure 4.6**).

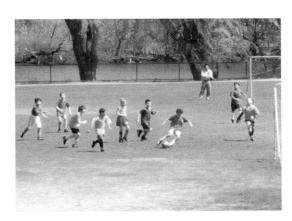

Figure 4.6 Although it won't be of optimal quality, a digitally zoomed shot gives you a picture that feels closer to the action.

Do's and Don'ts: Expect shutter latency

Do anticipate action. Unlike film cameras, digital cameras have a small delay between the time you push the shutter button and the moment when the picture is actually captured. The higher the resolution you choose, the longer the delay. Minimize missed shots by pushing the shutter button just a bit ahead of the action (**Figure 4.7**).

Figure 4.7 Pressing the shutter button just ahead of the action to compensate for shutter delay will let you capture the peak moment.

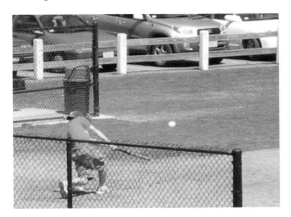

Athletic Events Up Close

Shooting action is more exciting when you can get up close to it. You also have many more options for capturing action when you can really see it. The key to your close-up action shots is shutter speed.

Changing shutter speed

Shutter speed—how long the hole that allows light into the camera is left open—controls the way a camera handles motion. A low shutter speed, where the shutter is open for a longer time, creates motion blur. A fast shutter speed appears to freeze motion, allowing you to capture action with clarity and precision (**Figure 4.8**).

Figure 4.8 The shutter speed was too slow to freeze the kicking motion, leaving a blurred foot in the picture. With a higher shutter speed, the kicking foot is clear while in motion.

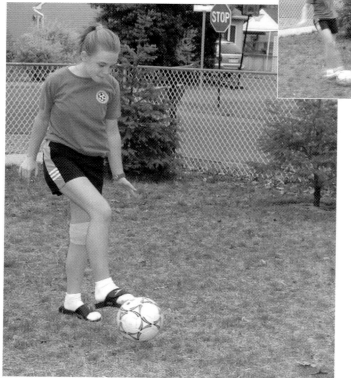

Although many digital cameras offer a way to set a high shutter speed, the methods aren't consistent among camera models. The easiest method is when the Fast Shutter setting is a separate camera mode. If your camera offers this function, you just select the mode, and shoot as you would normally.

If your camera doesn't have a Fast Shutter mode, it may have a Shutter Priority setting. This option is very much like a preset mode. Select it, and your camera will use its fastest possible shutter speed.

If your camera doesn't have any shutter setting, it may have a Snow or Beach mode. Although these presets are meant for specific purposes, they also have a fairly fast shutter, so try them if you're shooting action in full daylight.

TIP: Some camera models offer Slow Shutter mode. In this mode, any movement of the subject will create motion blur, giving the impression that something is moving faster than it really is (**Figure 4.9**).

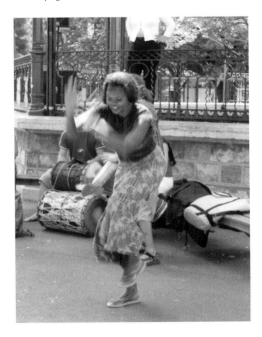

Figure 4.9 If you switch to Slow Shutter mode, you'll emphasize the speed of the dancer's hands.

Do's and Don'ts: Staying aware

Don't get so caught up in shooting that you lose track of where you are. Athletes concentrate on their performance or the game around them, not the audience. Don't interfere, or get in the way of action. A foul ball hitting your camera could really ruin your day.

Shooting Continuous Action

In some situations, like during a softball game, action starts and stops. You can anticipate the time frame during which something might happen, and then shoot as it takes place. Action is much harder to pin down when it's a continuous process, like at an air show or a race. You could opt to shoot a movie (see "Filming Pet Antics," below), but then you wouldn't have individual pictures to print.

Multiplying shots

Fortunately, many cameras have a multiple-shot, or Continuous-Shooting, setting. You can shoot two or more pictures in a row just by holding down the shutter button and aiming the camera. If you have lots of space on your storage card, you can get a nice series of shots in a short time (**Figure 4.10**).

TIP: The flash doesn't work when you're using the continuous-shooting setting.

Continuous shooting is usually a menu selection. That's good, because it means you can combine it with a fast shutter mode to shoot several "frozen" shots in a row. However, be aware of shutter latency (see "Do's and Don'ts: Expect shutter latency," on page 63).

Two things determine how much time the camera waits between shots:

* The resolution and quality settings you've chosen will affect the latency time. If you want shots to happen very quickly, you'll need to sacrifice some image quality.

* Some cameras let you specify the latency time, offering a choice between the shortest possible interval and one with a longer pause.

Remember to return the camera to single-shot mode right after you get your series, or else the next time you shoot you could end up with an unintended group of shots.

Figure 4.10
We set the camera to Continuous-Shooting mode, held down the shutter, and captured three very different Boston Marathon running experiences in the space of two seconds.

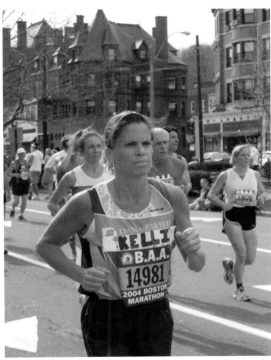

Do's and Don'ts: Adding drama to your shots

Don't just concentrate on the action. Sometimes the most dramatic part of an action sequence is not the action itself, but the human reactions to it. Look for opportunities to capture an athlete's determination, elation, or dismay (**Figure 4.11**).

Figure 4.11 Paying close attention just after the peak moment can give you a great reaction shot.

Filming Pet Antics

Even continuous shooting can't always keep up with an animal's delightful unpredictability. The most satisfying way to take memorable pictures of your pet is with a digital video recorder; but if you don't have one, your digital camera's Movie mode is the next best thing.

A few things to keep in mind when using Movie mode:

* Set your zoom, and any other settings your camera allows you to change in Movie mode, before you start to shoot. You can't change settings in the middle of shooting.

* Hold your camera steady, even if your pet makes a sudden move. Movies are very sensitive to motion. Keep the camera motionless and pivot your body to the new position.

✳ Movies created with digital cameras have a very small frame size, so they won't come close to filling a computer or TV screen. However, that makes their file size relatively small— perfect for posting on a Web site or sending via email (**Figure 4.12**).

Figure 4.12 Movies from your camera can be played right in an email window.

Capturing Animals in the Wild

Few travel pictures are more memorable than the ones that capture wildlife in their natural habitat. But wild animals are even more unpredictable than pets. You can follow the guidelines for shooting them in Movie mode, but you probably won't be as happy with the results. The movie window is just too small for viewing details, or for capturing the animal's exotic environment.

To shoot good photos of a wild animal, follow these guidelines:

* Don't overzoom. The surroundings will give the picture a sense of scale and retain the image of the animal in its habitat (**Figure 4.13**).

Figure 4.13 A photo of an animal in its habitat tells a better story than a close-up.

TIP: Never harass an animal to get a reaction. Aside from the potential danger to you, it is not environmentally responsible and could harm the wildlife.

* Approach an animal slowly and quietly. When you reach a reasonable distance, pause and stand still as you frame the shot.

* As with athletic events, using the zoom feature is essential. Few animals like to be approached by humans and will move away if you get too close. Use the zoom to frame the shot so you can keep your distance.

* If there is a light or dark background, set the auto-exposure on the subject (**Figure 4.14**).

Figure 4.14 Wild animals are often found lurking in dark places. To make sure they stand out, focus the autoexposure on the subject, not the background.

Nature in Action

Fast Shutter and Continuous-Shooting modes will serve you well with most action shots. But because high-resolution shots take longer to record to the storage card, they can come up short if the action you want to capture is large scale, and worthy of a high-resolution picture. When you want to shoot action shots in TIFF, RAW, or high-quality JPEG mode, you'll get the best result by selecting one of your camera's manual modes and setting the shutter speed manually.

Do's and Don'ts: Adding sound

Do use sound to take notes. Many digital cameras allow you to record a few seconds of sound along with the picture. The camera's microphone quality is not very high, but it's fine for voice recording. Use it to remind to yourself about the details of the shot.

Use the function menu to choose Sound Record mode. The sound will record right after you take the shot, so you can get your picture and then record the name of the subject or location. Some cameras allow you to add sound in Playback mode, so you can annotate your shots later.

Using the manual shutter

If your camera allows you to shoot in TIFF or RAW, it probably also offers a way to set ISO in the menu when you switch to a manual mode. You may recognize the term *ISO* as the method for rating film speed. The higher the ISO number, the faster light creates an image on film. Using a higher ISO setting gives you more flexibility in choosing manual settings, such as shutter speed.

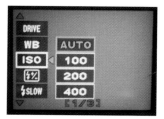

Figure 4.15 Changing the ISO to a higher number works the same way that setting a fast shutter speed does, but it gives you more control over the result.

Look in your LCD menu for an option to select an ISO setting. This setting imitates the way a film camera uses a "faster" film (**Figure 4.15**). If you raise the ISO setting from the usual starting point of 50 or 100 to 200 or 400, the camera will use a faster shutter speed and give you the frozen-motion effect you're looking for. There may be a slight trade-off in picture quality, but that sacrifice is far less noticeable when you're shooting with higher-quality settings (**Figure 4.16**).

Figure 4.16 A fast ISO setting—in this case 200—combined with careful anticipation captures this picture of a monster wave slamming into a 300-foot cliff.

Indoor Places

So much of life takes place inside houses and buildings, but if we could summon the perfect setting for photography, it would never be indoors. Indoor lighting changes the colors of things. Walls make it difficult to get the right vantage point, or distance, from a subject. Lamps scattered around a room create conflicting shadows. Luckily, digital cameras have tools to address many of these problems. Combine this great gadget with some savvy hints, and you can shoot indoors with the same success as you do outdoors on a perfect spring day.

Making Objects Come Alive

You'd think that taking a picture of objects would be easy. After all, you can put them exactly where you want them. They don't move in the middle of a shot, or start to cry, or blink at the wrong time. But the number of bad product shots on eBay makes it clear that objects can be just as challenging to photograph as people.

Taking the time to make your object look great can make a big difference in the photograph's impact—and, in the case of a situation like eBay, your potential earnings.

Creating a setting

Unless your object is too big to move (like grandma's mahogany china cabinet), give it the star treatment by creating a good shooting environment, not just shooting it where it stands (**Figure 5.1**). These tips will help you get the best result for your effort.

* **Increase your working space.** Maintain lots of space around your object to make it easy to select an angle for your shot, and so you can move comfortably.

* **Use a tripod.** You need a tripod to get a good, steady picture, particularly at close range.

* **Create a level surface.** If you have a white or black tabletop or other flat surface, you may already have a good surface. If you don't, buy a large sheet of white poster board to cover the shooting space.

TIP: If you don't have an indoor space that meets your needs, wait for a dry, overcast day, bring all your materials outside, and move to Chapter 6, "Outdoor Places."

* **Use a neutral background.** Shoot against a neutral, contrasting background. Flat white walls will do in a pinch, as will matte poster board pinned to the wall.

* **Optimize the lighting.** Shoot during the day, when the sun isn't shining directly into the room. If you have shades or translucent white curtains, close them.

Posing and shooting

Look at the object carefully to determine how to position it, and where to stand. Try shooting from slightly above the object, and use the fill flash to bring out details that might otherwise be hidden in shadows (**Figure 5.2**). The other plus of shooting from above is that, if the object is small, your surface becomes your background as well.

Figure 5.1 This sculpture shot is a typical eBay mistake. It's next to impossible to see what the figurine looks like, and the background shadow draws attention away from the subject.

Figure 5.2 Here is the same sculpture as shown in Figure 5.1, but shot from above in balanced light and with no distracting background elements.

Resolution and compression

If you are shooting pictures that will never be printed—
email attachments or online auction shots, for example
—keep your file sizes small. You don't want pictures to
transfer slowly and frustrate your intended viewer.

You may have to experiment a little before you find the
right combination of quality and resolution. Things with
fine details need higher quality settings, while large,
mechanical objects can often be shot at very low quality
and high compression. Before you shoot, read Chapter
2, "Digital Camera Basics," for an explanation of reso-
lution and how to select it.

TIP: Want to take a
picture of an object
that won't stand up
unless you hold it?
Think of how a jeweler
uses a velvet rack to
display a ring. You can
create a similar display.
Get a thick piece of
foam board and slice
it in the middle. Nestle
the object in the slot
you've made and posi-
tion it for your best
shot (**Figure 5.3**).

Figure 5.3 Try to get small objects like jewelry to stand
upright for the best view of them.

Enhancing Shots of Interiors

There's a difference between taking a picture inside a
room and taking a picture of the room. If you need an
interior picture for real estate purposes, or to highlight
your decorating skills, things that are often just back-
ground elements become important.

Using effective lighting

Light makes interiors tricky to shoot, because including
windows in the shot often make the room itself too
dark. Professional photographers solve this problem by
placing lights and reflectors strategically, but you don't
have to be a pro to get a decent shot. Your goal is twofold:
to take advantage of natural light, and to provide addi-
tional light from your camera to balance it.

Testing and setup First step: Take pictures in the room at different times during the day. When is there enough light from the windows to illuminate the room, but little or no direct sunlight? If you have a room with many windows, you may need to wait for an overcast day.

Once you've found the best time of day to shoot, set up your camera on a tripod. Make sure that all the lights in the room, and in the rooms adjacent to your subject room, are off. Artificial light adds false color and creates "hot spots" (**Figure 5.4**).

Figure 5.4 This could have been a great interior shot, but the artificial lighting has turned everything red and created bright pools of light.

TIP: Once you've changed your camera to a manual mode and selected some settings, these selections will usually remain in the camera. If you don't usually use manual settings, return your camera to its default settings and switch to automatic mode at the end of the shooting session.

Setting exposure Change your camera mode to a manual setting. Some cameras have only one manual mode, in which case you have to determine every setting for yourself. Shooting is easier if your camera has a semimanual mode that helps you with focus and shutter speed, but lets you change exposure and flash settings.

Find the Exposure Compensation menu, which may be available only in a manual mode. It's often part of the White Balance menu. Because every room's lighting is different, you'll need to test several exposures to find the best one. *Bracketing*—shooting several shots with varying amounts of exposure—is your best strategy.

You want to overexpose the pictures slightly so that the room won't be too dark compared with the light from the windows, so use your camera's up/down controller button to move the pointer on the exposure bar to the + side. Moving up to + 1 is a good bet (**Figure 5.5**).

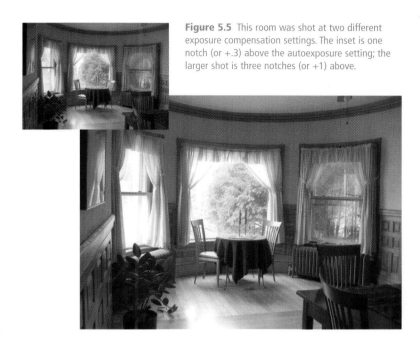

Figure 5.5 This room was shot at two different exposure compensation settings. The inset is one notch (or +.3) above the autoexposure setting; the larger shot is three notches (or +1) above.

Some cameras have an option that brackets for you (sometimes called AB, or automatic bracketing). You select a range for the shutter aperture, and the camera shoots several times consecutively but at different points at the exposure setting so you can quickly compare the results and select the best exposure (**Figure 5.6**).

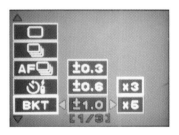

Figure 5.6 The LCD here displays the Auto Bracketing menu. It will shoot a series of images with exposures between −1 and +1.

Flash or no flash? If your windows are at the edge of your shot, you will probably turn the flash off, and just use a high exposure-compensation setting to drink in as much natural light as possible. If you are shooting directly at your windows, turn the flash on and use the fill-in setting (**Figure 5.7**).

Figure 5.7 Adding Fill Flash equalizes the light from outside, making it possible to see this interior clearly.

Point of view

People like spacious interiors. Shoot from an open door, or select a good room corner. Shooting down on the room expands it even more, so you might get your best shot by standing (or positioning your tripod) on a stepladder or high chair (**Figure 5.8**).

Figure 5.8 Placing the tripod a few feet higher in the room to shoot from slightly above makes it appear more spacious.

TIP: Need to spice up your picture? Add a color accent in the center of the shot: Put colorful flowers in a vase, or find a bright cloth runner to place on a table (**Figure 5.9**).

Figure 5.9 Create a color focus with a shock of red and brighten the room.

Do's and Don'ts: Trusting your LCD

Don't always trust what you see on the screen. The LCD monitor gives you instant access to your shots, but the camera's display is so small that it can be difficult to accurately determine certain aspects of a photo.

Subtle focus problems are tough to see in the camera display. If you're shooting indoors with the flash turned off, the photo may look good on the display. But when you view it at full size, you might find that the shutter speed was too slow and the shot is blurry (**Figure 5.10**).

Since you don't have to worry about wasting film, always take several shots—with and without flash—to make sure that you get one that you want.

Figure 5.10 Even if a shot looks good in the camera's display, it may be blurry at full size.

Inside Cathedrals or Museums

Lighting in museums or cathedrals is often muted (**Figure 5.11**). A lot of artwork is sensitive to light, so you often aren't allowed to use a flash in these places. Even if you are allowed to do so, the flash may not be effective. (See "Do's and Don'ts: Effective flash distance" later in the chapter.) A few clever strategies will solve the majority of problems with the museum shots you used to throw away.

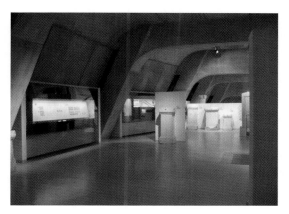

TIP: Before you shoot in a museum—even without a flash—ask if photography is permitted. Sometimes you aren't allowed to take pictures at all.

Figure 5.11 Museums are lit to emphasize individual exhibits, not to illuminate the entire room.

Balancing the light

If you're using a flash, it will provide properly balanced light to the area it illuminates. But when the flash only reaches the subject, the background may still show a color imbalance. That's most likely to happen when the light in the room is artificial—fluorescents, regular light bulbs, or halogen spotlights. To solve this problem, select White Balance from the LCD menu. Since you're indoors, try the Tungsten setting to match background to subject (**Figure 5.12**).

WB

Figure 5.12 This room presented a challenging combination of light from the window, incandescent bulbs, and the camera's flash. Using the Tungsten White Balance setting neutralized the bulbs, providing room colors that were true.

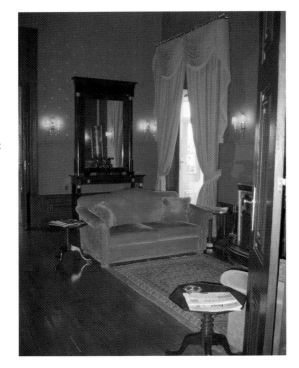

Avoiding too much light

In a dim space, the flash can be too bright. With a close-up in particular, it can blaze so strongly that the other elements—shadows, texture, and patterns—lose their shadows and bleed to whites and pastels (**Figure 5.13**). If that happens, choose a manual mode, select the flash exposure-compensation setting in your LCD menu, and decrease the strength of the flash before you shoot. If your camera doesn't have this setting, turn the flash off.

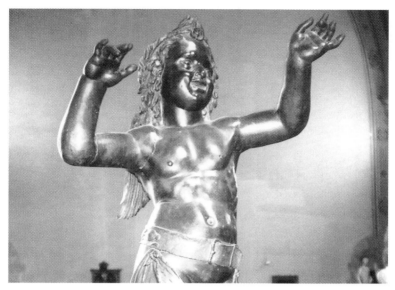

Figure 5.13 When the flash is too bright, the subject becomes white in some areas and too dark and contrasted in others.

Getting enough light

If you've eliminated the flash, you need another way to get enough light on your subject. The more seconds the shutter is open, the more light the camera takes in. Eventually, you'll have enough light for your shot.

Adjust shutter speed Most cameras let you set shutter speed through a menu display, but you must be in a manual mode. Look for references to "slow shutter" in your manual if you're not sure whether your camera lets you do this. Shoot test shots to see when you're capturing enough light, and adjust the speed up or down as needed (**Figure 5.14**). If your camera doesn't seem to let you set the shutter speed, look for a preset mode with a name like Twilight. This is always a slow shutter setting.

TIP: Look out for people walking in front of your camera during a long exposure. Get their attention—point to the camera. Most people are willing to wait for a few seconds.

Figure 5.14 The picture at the right was taken with the autoexposure and autofocus. People are sharp, but the image is far too dark. In the photo above, the exposure has been held open. Some people are blurred because they've moved, but the beautiful spiral staircase is clear.

Flash off, tripod on Because you keep the camera lens open longer, you need to hold the camera still. One of the surest methods of getting sharp shots without a flash is to use a tripod or monopod. A monopod (one-legged tripod) is easier to lug around and less hassle to set up.

If you don't have a tripod, you can place the camera on a table or bench to hold it steady. If you sit down to get the shot, try putting your elbows on top of your thighs to form a steady platform. If you're leaning against something for balance, tuck your arms against the front of your body and cup the camera in your hands to create a human tripod.

Do's and Don'ts: Turn off your camera sounds

Be considerate of those near you. Many digital cameras make noises when you turn them on, or mimic the sound of a film camera's shutter click when you take a picture. Although these features can be handy, they can annoy people around you. If you are shooting in a quiet place, use the camera's menu option to turn the sound off. This option is usually found in the camera's setup settings.

Shooting through glass

Shooting objects in store windows, or museum exhibits behind glass, presents challenges. The flash will nearly always reflect off the glass, and the glare will obscure whatever is behind it.

Change your angle

To eliminate the glare, try shooting at an angle. Stand slightly off to one side so that the camera's aim is not perpendicular to the glass. Line up the shot at this angle and take the shot. Check the picture in the camera's display to see if the glare is visible. If it is, try a different angle and check again (**Figure 5.15**).

Figure 5.15 The flash creates glare when it's aimed straight at the glass (inset). Moving the camera to one side eliminates the glare.

If you're still having problems, maybe the issue isn't your angle, but where the light is. If it's behind you and shining on the glass, you're guaranteed to have glare. If you can, move to the opposite side for your shot. Override the autoexposure setting by angling the camera away from the light opposite you and pressing the shutter button halfway. Reframe and then take your shot.

Shoot without the flash

If you can't get a shot without glare or if flash photography is not permitted, try shooting without the flash, following the instructions in "Inside Cathedrals or Museums" earlier in the chapter. You may experience some shadows and color shifting, but chances are the glass will disappear from the shot (**Figure 5.16**).

If the object you're trying to shoot is small and at eye level, move in as close to the glass surface as you can—so close that the camera actually touches the glass if possible. This will help balance the camera and eliminate the glass layer when you focus.

Figure 5.16 If your exhibit has good spotlights, you may not need the flash. In this shot, you can't even see the glass protecting the exhibit.

Do's and Don'ts: Effective flash distance

Don't waste your batteries on pointless flash shots. A flash works best when you are within a few feet of your subject. It doesn't work at all if you are further away than the flash range, which for most digital cameras is between 12 and 16 feet. Using a flash when you are too far away from your subject will usually result in no picture at all (**Figure 5.17**). It can even make your photo worse, by shining light on something closer at hand.

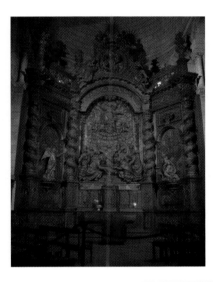

Figure 5.17 Despite the ambient daylight and the camera flash, this carved altar is barely visible. The flash was too distant to illuminate the carvings.

Outdoor Places

You will probably take more pictures outdoors than inside. Mountain vistas and city skylines are the stuff of great photographs. But outdoor photography presents as many challenges as indoor. Compensating for light changes, properly focusing for close-ups, and getting good landscape shots are all made easier by using the camera's tools and developing a good photographic eye.

Getting Crisp Outdoor Close-Ups

Close-ups often make very compelling and attractive pictures. They give viewers a glimpse of something they might never have looked at closely before. The classic example of a close-up shot is a colorful flower, but almost any unusual detail will do, particularly if there's a lot of contrast between your subject and its background. Unfortunately, the autofocus feature on most digital cameras won't operate correctly unless you are at least 2 feet from the subject. At that distance, you're too far away for real impact. When you want to get a picture of something closer than that, you need to use the macro focus setting.

Using macro focus

When you select macro focus, you tell the camera that you are very close to the subject. Instead of looking for a normal-range object and blurring your subject, it will automatically adjust the focus. Don't get closer than your macro setting can focus. On a digital camera, that's usually between 3 and 4 inches.

To use macro focus, press the macro focus button, get close to the subject, and frame it using the LCD monitor. Hold the shutter button halfway to lock the focus and then press it all the way to take the picture (**Figure 6.1**).

Figure 6.1 Macro-focused shots are best when the subject's colors are strong, and contrast well with the background.

Don't forget to turn the macro focus off if you plan to continue shooting at normal distances, so the autofocus can operate correctly. If your camera shuts down or you turn it off, however, the camera will turn off the macro setting automatically.

Bringing Home Architecture and Sculptures

Buildings and large outdoor art are a photographic puzzle, because they seem very easy to shoot well, but in fact can be quite difficult. The size of a building, lack of good angles to shoot from, and the difficulty of getting the entire façade in a one shot make architecture a challenging subject. It's tempting to just point and click, because you've got good natural light and the shot is almost always in focus. But by paying attention to a few of the elements around you, you can turn an OK shot into a good one.

Watch your background

Classical sculpture is usually light-colored. If you shoot it against a cloudy or hazy sky, you'll have a tough time seeing details. Shoot it on a bright day at noon, and you run the risk of turning the sculpture into an outline. Look for a way to get a shot with the sun behind you, and find a place to stand that gives you a contrasting

background to set the statue or building off (**Figure 6.2**). If your subject is not too big and you're within effective flash distance (see "Do's and Don'ts: Effective flash distance" in Chapter 5), select the Fill Flash option to avoid a silhouette and to capture richer detail.

Figure 6.2 On a hazy day create more contrast between background and sculpture by getting the light behind you and setting the autoexposure on a shaded part of the sculpture before you shoot.

Don't get too close

It's a rare event when you'll be shooting a monument or building from above. Shooting from below can work to your advantage if you are trying for an artistic effect that emphasizes height and outline (**Figure 6.3**). Otherwise, if you want to avoid distortion, you need to change your angle. Get as far away as you can from the object without getting out of comfortable zoom range. Moving away will put things back into proportion, effectively making the object smaller. Zoom in to bring the subject back into focus (**Figure 6.4**).

Figure 6.3 Shoot close to a subject to capture mass and form.

Figure 6.4 Pull back and shoot from a distance to see more of a building, and its context.

Capturing details

Nothing makes a better and more memorable picture than a beautiful architectural detail. You can always buy a postcard of the façade of a famous building, but some careful observation will provide a unique picture that sparks your memory more effectively. In city neighborhoods, look at doorways, signs, windows, and decorative trim. In a country setting, cozy up to fences, barns, and stonework (**Figure 6.5**).

Figure 6.5 Architectural or decorative details are everywhere. Look at doors, windows, metalwork, and other visual elements.

Use landscape to provide context

Some buildings or monuments are so fascinating that they command attention without help—look at the White House or Big Ben. You can shoot the picture without worrying about the surrounding buildings, cityscape, or environment they're in. But frequently, the thing you're most drawn to about a building isn't just its shape or color, but how it looks in its setting. Before you shoot too close, or focus too narrowly, pull back and look at the environment. Your picture will probably be more memorable if you can anchor the building in its setting (**Figure 6.6**).

Figure 6.6 Different buildings need different vantage points. You can pull back from a building to see its context on a narrow street, or pull back into the countryside to show the grandeur of a manor house.

Use people to provide scale

When you're shooting, you're completely aware of the size and distance of your subject. But if you don't include some familiar element to provide a comparison, people looking at your picture later often won't understand why you thought the shot was worth taking. Whenever possible, use a person—friend, family, or simply a passer-by—to help provide a visual yardstick (**Figure 6.7**).

Figure 6.7 Without a human being in the shot to provide scale, this arch could be any size.

Create movement

Movement in a piece of stone? Sure! Every time you see a staircase, you can instinctively imagine walking up or down. Get great shots of architecture by using walls, stairs, and twisting roads to create a path of motion through an image. This helps to make a picture feel three-dimensional, and will engage a viewer's interest later (**Figure 6.8**).

Figure 6.8 These stairs invite you to follow them upward.

Do's and Don'ts: Think about framing

Do think like an artist. Your first instinct when you set up a shot will often be to put the subject in the center of the frame. But that doesn't always make for an interesting photograph.

Artists use the *rule of thirds,* dividing the picture frame into nine sections. Visualize a tic-tac-toe grid of evenly spaced horizontal and vertical lines (**Figure 6.9**). By putting the main subject at (or near) one of the four intersections of these lines, you can create a more interesting shot, as the viewer's eye is naturally drawn to elements at those intersections.

Don't feel that you have to use this rule every time. But you'll probably find that most photos look better with this kind of balance.

Figure 6.9 With the butte in the center of the frame, this is a fairly ordinary snapshot. When you position the subject just a bit out of the center, the photo becomes much more visually interesting.

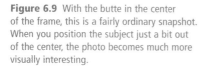

Shooting a Panorama

Capturing the sweeping vista of a vast landscape in a single shot is usually impossible. Zooming out to include the entire scene renders everything so small that the sense of open space is lost. The details become so small that they're unrecognizable (**Figure 6.10**). But what if you could take a series of shots and put them together later to create a larger single picture? If your camera has a Panorama feature, you can.

Figure 6.10 When you attempt to get too much of the vista, the details end up too small to be appreciated.

A digital camera with a Panorama function opens up an exciting world of photography. Pieced-together panoramas shot with film cameras are almost always disappointments. One side of the shot is often darker than the side of the other shot that should attach to it, and tops and bottoms don't align. But with digital cameras, even a point-and-shoot photographer can end up with a remarkably dramatic finished photo (**Figure 6.11**).

TIP: Even if you have a camera with a Panorama function, the panorama isn't created automatically. You will need to merge the individual shots using a computer. In most cases, *stitching software* comes with a camera that offers a Panorama feature. This software not only merges the images, but it also adjusts the light and color to hide the stitched seams.

Figure 6.11 A panoramic view is the only way to capture the majesty of Rome's ancient forum.

Setting up for the big picture

No matter what camera and software you use, your original images must be suitable for stitching together. You can do a lot during shooting to improve the end result.

* Stable shots are good shots. You don't necessarily need a tripod, but you should remain as still as possible while you shoot. Stand with your feet apart and move only your upper body. Move slowly and pay attention to the panorama display.

* Try to shoot in dependable lighting. If the sun is going in and out of clouds, try to take your pictures at a time when every shot will have about the same brightness.

* Create a *baseline*. When you compose your shots, try to create a horizontal place in the image that you can treat as the bottom of each shot.

* Overlap. At least one-third of the material in one photo should appear in the next one as well. Half is even better (**Figure 6.12**).

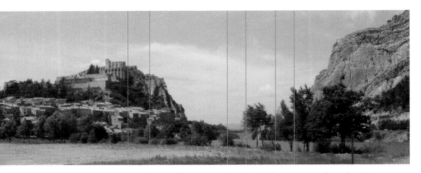

Figure 6.12 The green outlines in this panoramic shot indicate areas of overlap. The more overlap, the better the seams between the individual pictures.

TIP: Most cameras label panorama shots in a special way, so remember to return your mode setting to Single Shot after you've shot a panorama.

* Keep count of the shots. Check your camera documentation before shooting images you'll want to stitch together. There may be a maximum number of photos you can shoot to create a panorama. If you run out of shots before you finish, you can create a second panorama, but merging the two finished pieces together may be less successful than one continuous group of shots.

Facing the Sun

One of the basic rules of photography is to shoot with the sun at your back. Whatever you're trying to capture will be illuminated, and your camera's automatic functions will work well. That isn't always possible. But when you have to shoot into the sun or another bright light source, the camera is tricked. It sets the exposure too low for the shot, and the darker areas lose detail.

Adjusting exposure

In many cases, there's a simple solution to the problem of shooting into the light, mentioned in Chapter 2, "Digital Camera Basics": Temporarily reframe the shot with the subject (the darker area) in the center of the frame. Press the shutter button halfway down and hold it. While holding the button, reframe the shot and push the button all the way down (**Figure 6.13**).

Figure 6.13 The bright sky behind fooled the autoexposure and left the statue underexposed. Setting the exposure on the horse results in a good shot.

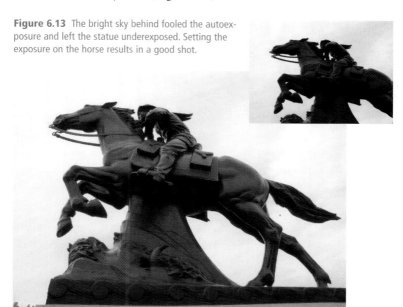

The sun may be too close to your subject for this strategy to work. If so, select a darker area elsewhere in the shot—a light shadow, or an area on the ground. Avoid high-contrast shadows, because they'll throw the exposure off in the opposite direction.

Sometimes there is too big a difference between the brightest and darkest areas to get the exposure just right. In that case, you can use the bright area as a picture element, creating a nice visual contrast with the rest of the picture (**Figure 6.14**).

TIP: If you're shooting at midday, the sun can overwhelm your shot even if you're not shooting directly into it. The simple strategy of shading the lens with your hand will help the camera avoid overexposure.

Figure 6.14 The bright foreground is a nice contrast to the shaded background.

Shooting Landscapes

Even though daylight is considered the standard for capturing accurate colors, in fact there are different types of daylight. Light in the great outdoors shifts according to weather, locale, and time of day. We often don't notice, because our eyes adjust to the light at hand. But the camera captures this shift, producing a picture that looks tinted as a result. When shooting landscapes, you can adjust a digital camera's settings to compensate for these shifts, or to enhance them for effect.

Sunrise, sunsets

No trip to the big sky or sea is quite complete without the obligatory sunset photo. These shots capture the difference between the daily grind of your usual life and that special vacation feeling. And sunsets just generally make good subjects. Colorful, compelling and infinitely variable, they're fun and satisfying to shoot.

Each sunset is unique, and how you shoot it can give you a wide variety of effects. Because sunsets are all about colors of light, a simple shift in where you point your camera can change what you capture. Shoot to maintain the landscape around you, and your sunset will be

brighter and more pastel-colored. Shoot straight into the sunset, and foreground elements become silhouetted, while the sunset itself becomes darker, with stronger colors in the sky and clouds (**Figure 6.15**).

Figure 6.15 These two sunset pictures have different effects. The upper shot was taken earlier, with its focus on the distant setting sun. The lower one pulled back to take in the passing ship, and the people watching the sunset in the Florida Keys.

Besides selecting for brightness, you can use your camera settings experimentally to mimic a filter effect on a film camera. Go to your White Balance setting, and select Tungsten to add a cool blue tint to your sunset, or Fluorescent to make the colors redder and warmer (**Figure 6.16**).

Figure 6.16 This was already a beautiful sunset, but by changing the white balance setting, it becomes even warmer.

Night shots

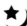

Taking night pictures often involves either a vista like a city skyline or a picture of something in the foreground with the vista in the background (**Figure 6.17**). Both situations require a bit of effort to get a good shot.

When shooting a skyline at night, turn off the flash so that the autoexposure uses the distant light. Since this shot will require a long exposure, use a tripod, or rest the camera on something.

When you want a shot of something in the foreground but still want the background to be properly exposed, you need to use the Night Scene setting. With this option, the flash will fire to light up the foreground, and the shutter will take a slightly longer exposure to get the background. As with the No Flash setting, the long exposure will require a steady platform to avoid a blurred shot (**Figure 6.18**).

Figure 6.17 Without the flash, the autoexposure gets the proper setting from the skyline.

Figure 6.18 The camera's Night Scene mode illuminates the foreground and captures the background crisply.

Overcast sky

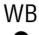

When the sky is overcast, the light will be bluer than on a sunny day, since the clouds filter out a certain amount of red light.

To compensate for this, you can use the White Balance feature for a cloudy day By adjusting for the lower amount of red light, this setting will give you a more accurate representation of the scene (**Figure 6.19**).

Figure 6.19 Thick clouds rendered this scene more blue to the camera than it appeared to the human eye (inset). Setting the White Balance to Cloudy Day restored the reds and provided a truer picture of the park.

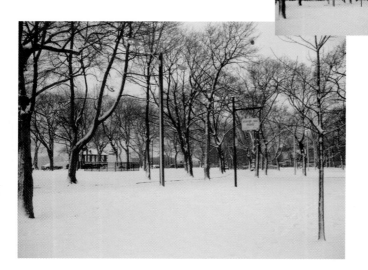

Challenging Settings

The digital camera is a smart device, but it can't always judge the effect you want, or take the place of your own creativity. It's also easily fooled by extreme lighting, and doesn't always focus on the things you really want to capture. When the setting is challenging, you'll want to take advantage of and experiment with your camera's presets and manual modes.

In the snow

In extreme conditions, like on ski slopes, the overall brightness overwhelms the camera. The snow ends up dirty gray, and people in the foreground become silhouettes. Some cameras have a Snow mode to adjust specifically for this problem.

If your camera doesn't have this preset, use a mode that lets you change exposure. Increase exposure compensation to force the camera to capture more light. Use the up arrow controller on your camera to move the exposure one step up (+1 EV). This small change can make an enormous difference in color range (**Figure 6.20**).

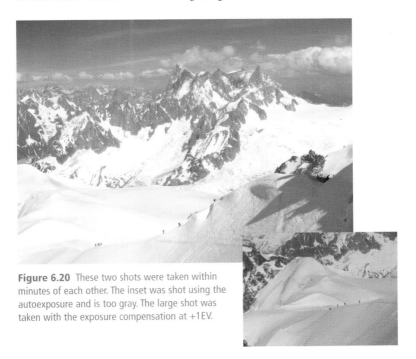

Figure 6.20 These two shots were taken within minutes of each other. The inset was shot using the autoexposure and is too gray. The large shot was taken with the exposure compensation at +1EV.

In the woods

Have you ever shot a picture in the woods, and wondered why a scene you remember as dark and dense ended up gray and muddy? That happens most frequently when you are trying to shoot a person or animal against the darkness of the trees. The camera sees more dark than light, and overexposes the scene to add light to it. Go to exposure compensation and move it into the minus range. You'll want to play with a couple of different settings, depending on exactly how dense your forest is. Start with −2 EV, and decrease if it creates too dark an image (**Figure 6.21**).

Figure 6.21 Exposure compensation results in a more accurate picture when autoexposure doesn't do the job.

With a distracting background

Digital cameras are very good at making everything in a picture sharp, whether the scene you're trying to capture is close to you or far away. That's great when you're taking pictures of people in beautiful scenery, but not so good when you're taking a picture with an unattractive or dominating background. Some cameras have a Portrait mode to help eliminate background distractions. But Portrait mode may not blur the background enough (**Figure 6.22**).

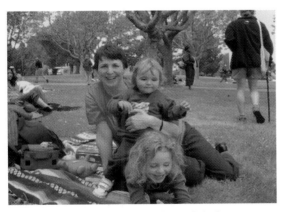

Figure 6.22 This is a fun pose, but the people in the background are so sharp that they distract from the subjects.

If your camera has a manual focus setting, this is a good time to use it. When you select this mode you should get a display on the LCD that toggles up and down to set a distance from the camera. This display is not always completely accurate, so use it as a visual guide, not as an exact measurement.

Select an object that is just a little closer than the thing you want to capture, and adjust the manual focus setting until it appears nicely focused on the LCD display. Frame your picture and shoot. Your background should become blurry and distorted, but the thing you're trying to capture should look fine (**Figure 6.23**).

Figure 6.23 Close-ups and other detailed images require a nondistracting background.

Do's and Don'ts: Early birds and late risers

Don't assume that all light is created equal. Most people on vacation take their pictures in the middle of the day. Although full daylight makes it easy to take a clear, sharp picture, the result can sometimes be hard and flat. For outdoor pictures you want as keepsakes, try shooting early in the morning and late in the afternoon, when the sun's rays are at an angle. You'll get warm, rich colors (**Figure 6.24**).

Figure 6.24 The warm, rosy light of sunset makes most subjects richer and more vivid.

After You Shoot

Your digital photography experience isn't over once you've pushed the shutter button. You have much more control over your pictures than ever before. Unlike with a roll of film, whose contents are a mystery until they are developed, you can preview any image on your storage card in a variety of ways, and decide whether it's worth keeping before you expend any more storage space or time on it. You can drop your storage card off for processing the way you once dropped off a roll of film, print directly from your storage card, or become your own photo finisher by transferring your pictures to your computer and editing them to your liking. And you can do all of these things completely at your own convenience.

Reviewing Images in the Camera

After you've taken pictures, you'll want to review them to make sure that important shot came out right.

To review your work, put the camera in Playback mode. Usually you select Playback mode by pushing or clicking a button on the camera. Some clamshell cameras will play back your photos when you push the cover halfway toward the Off position.

In Playback, you can use the Right/Left toggle buttons to go through the shots one at a time. On some cameras, the Up button takes you to the first shot on the card and the Down button to the last. Other cameras may use the Up/Down or camera zoom buttons to let you magnify a picture so you can see details more clearly.

Date and Time Stamps

A digital camera does more than take pictures. It gives them names and attaches information to them. In addition to the date and time, most cameras record the resolution setting, image size, and other data about each picture. This is called the *EXIF data*. You can see this information on the camera's display. Even better, this data transfers with the picture to your computer.

TIP: With most cameras, you'll find a menu option that lets you select how to number your images. The camera can remember the numbers of previous shots to avoid duplicate names, or it can reset the numbers to zero each time you put in a new storage card.

Setting time and date

To keep track of the date information, the camera must know what time it is. You must first set this using the function menu. In the Camera (or sometimes Mode) Set Up screen, choose the date and time options. Using the arrow buttons, set the current date and time (many cameras use the 24-hour time system). When the settings are correct, press OK to save the changes.

If your batteries ever completely die in the camera, check the time and date settings after you put in fresh ones.

Do's and Don'ts: Take advantage of your review options

Do make your camera work for you. Most digital cameras have more than one playback option. Besides viewing your shots sequentially, you can often jump quickly to an earlier or later group of images—handy if you have a storage card with lots of capacity. Or you can use your camera's multiple-image replay to see several pictures at a time—particularly useful for comparing several shots you may have taken at different settings (**Figure 7.1**). Last but not least, if your camera offers a slide-show feature, you can use it to share all or some of your pictures with others while the images are still in the camera.

Figure 7.1 This camera's playback options allow you to view nine images at a time, and jump quickly to another group of images you shot earlier or later.

Erasing Images

When you view shots in the camera, you may want to get rid of the ones you don't want so that you can free up room on the storage card. While in Playback mode, bring up the shot you want to delete. Press the Delete button and then the OK button to confirm the deletion.

Digital cameras make it easy to erase one picture at a time, but sometimes you'll want to erase a storage card completely. Because doing this is a drastic step, this option is always found on the LCD monitor menu—a place you must visit deliberately, not by mistake. Look for a menu option that says "Erase all" or "Format card." Highlight it, then select OK. You'll be asked to confirm that this is what you really want to do.

TIP: Once you have deleted a picture on the camera, it's gone for good. If you have any doubts about a shot, it's best to leave it alone and delete it later, after you've transferred it to your computer.

Protecting Your Shots

Hopefully, you've taken wonderful pictures that you're itching to turn into beautiful prints or to share online. Until you're ready to process the shots, you can take a few steps to ensure that they'll still be there when you're ready to transfer them.

Lock your prints

When you won't be transferring your shots to the printer or computer immediately and you are sure that some of your shots are keepers, you can protect against inadvertently erasing them from the storage card.

In Playback mode, bring up the shot you want to protect. Press the Lock button and then the OK button to confirm the lock. You will not be able to erase the shot unless you go back and use the same process to unlock it.

Stay charged up

If you shoot while the low-battery symbol is displaying, you could corrupt the memory card holding your shots, possibly losing all the pictures you've previously stored on it—even ones you've locked. The best way to avoid such a loss is to keep your batteries charged.

Since charging can take several hours, charge your batteries the night before you'll need them. When changing batteries, *always* make sure that the camera is off.

Keep track of your storage

When you have lots of photos to take and you're going to use several storage cards, mark each card after removing it from the camera. You can use a magic marker to write a number on the card. By numbering the cards, you do two useful things. First, you have a way to keep your shots in chronological order. Second, you're less likely to miss shots (or to have to delete older ones) by putting a full storage card in the camera by mistake.

Do not write over, or put a sticker on, the contacts when using cards like SmartMedia that have exposed metal parts. If you use a sticker or Post-It note as a label, be sure to remove it before inserting the card into the camera or a card reader.

Transferring Your Files

Unless you will take your storage card directly to some-place where they print for you, you'll have to transfer your picture files from your camera. There are two ways to do this: transfer directly to a printer, and transfer to the computer.

Transferring to a printer

Some cameras offer an optional accessory you can buy that lets you attach your camera directly to a photo printer—one that has been designed to read picture information without the need for a computer. If this describes your equipment, all you need to do is to con-nect the camera and printer according to the instructions in your manual, and then manage your prints right from the camera's or printer's LCD menu.

Transferring to a computer

To take full advantage of a digital camera, you need to transfer your pictures to a computer. With a computer, you can do more than just print a picture. You can crop away bad parts of photos, fix the red eye your camera didn't prevent, and combine your pictures with text to make everything from greeting cards to newsletters. With a little software and some imagination, there's almost nothing you can't create—from fine art to the wildest tabloid newspaper shot.

The two most common transfer methods are to plug the camera directly into the computer's USB port or to use a card reader for cameras that can't plug in directly.

TIP: If you are an AOL user and you want to send and receive photos outside of AOL, you should begin by upgrading to at least version 7.0. If you don't want to do that, you should compress everything you send out as an attachment. AOL uses as its email compression program whatever is standard on your platform: ZIP for Windows, SIT for Macs. You should tell your recipient what type of compressed file (ZIP or SIT) they'll receive.

Some cameras or computers that are more than five years old may require additional software to connect, but more recent equipment should work without a hitch.

Your computer may have software that automatically recognizes that a camera is attached to the system. If so, the software should start up once you attach the camera. The software will then transfer the files automatically, and allow you to delete the pictures from your storage card when the transfer is complete.

If you don't have software that starts up immediately, your computer should still recognize the camera or storage card. The camera or card will look and act the same as a disk. On a Windows machine, it will appear as a lettered drive (E: for example) in My Computer. On a Macintosh, it will appear on the Desktop.

Once you see the new disk, you can double-click to open it (**Figure 7.2**). You will see a folder, inside which is another folder that contains your picture files. (They will have names like P1010003.JPG.) Create a new folder on your hard drive (not on the camera/storage card). Then select all of the picture files and drag them to the new folder.

Once you've transferred the pictures, you can delete the files from the camera or card. (If you have a Mac, don't forget to "Empty the Trash.") You can then eject the card.

TIP: Never try to edit or change a picture before transferring it out of the camera. You could damage the format of the storage card.

Figure 7.2
When plugged into a Windows (left) or Macintosh (bottom) computer, the camera is represented by a disk icon, with the pictures in a folder.

Emailing Your Pictures

Aside from printing, the most common method for sharing your photos with others is via email. It's a simple matter to attach a picture file to an email message and send it anywhere with a click (**Figure 7.3**). There are just a few things that you should keep in mind:

✳ JPEG (the default format for your camera) is the accepted standard for photos sent via email. If your pictures are in TIFF or RAW format, you'll need to resave them as JPEG files before you can send them.

✳ If you have photo editing software like Apple's iPhoto or Adobe Photoshop Elements, you can make a smaller version of your pictures to send to people who read their email using a dial-up service. If you're not sure what kind of Internet connection your intended recipient has, you might want to check with them before sending a large file.

✳ When you send two or more pictures at a time, put them in a folder, then prepare the folder with a program that compresses it and sends the pictures as one attachment.

Figure 7.3 If you send a picture as an attachment, the person you send it to can usually view it right in the email window.

✳ In Windows, you'll need compression software that creates ZIP files. The best-known programs to do this are WinZip (www.winzip.com) and PKZIP (www.pkware.com). (Some computers come with WinZip installed as a trial application.) On a Macintosh, you'll need either StuffIt or StuffIt Deluxe (www.stuffit.com) to make SIT files.

Once you have the file you want to send, create a new email and attach the file either by dragging it into the message window or using the Attach File command.

Printing Your Pictures

We love the instant gratification of seeing pictures onscreen, but there's still nothing like having a color print. Fortunately, it's just as easy to make prints from your digital images as from traditional film.

Whether you're printing your own or having them done at a store (or online), choose your print size carefully. Refer to the table "Megapixels and Printing" in Chapter 1 to figure out what print sizes you can select, based on the resolution and quality settings you used to shoot your pictures.

Printing for yourself

It's very convenient to drop off a storage card at a store and pick up the pictures when they're done, or to upload shots for processing online. But you may have purchased a camera that comes with a photo printer, or already have a photo printer at home. In that case, you'll find it much more convenient to print your shots yourself.

Do's and Don'ts: Burn a CD of originals

The best way to ensure that you have a permanent record of your photos is to burn a CD with the original shots. Even if you have computer disaster, you'll always have a backup of your important pictures.

After you've created the CD, feel free to experiment with your shots on the computer—lightening, darkening, cropping, and any of the myriad other things you can do with photo software. If you mess up, you can always go back to the original on the CD.

When you are shooting your pictures, think about whether you plan to print them. If so, use the highest-quality camera settings for those shots. If your camera has the option of using a TIFF or RAW file format, these will give the best prints. If not, use the highest-resolution JPG setting.

To print from a computer, open the picture in your photo software. Make any changes you like, save the file (or save as a copy if you want to keep the original unchanged), and choose the Print command.

If your printer is one that can read pictures directly from your camera, you can manage the printing from the camera as well. Using the camera's LCD display, bring up the picture in Playback mode; you can then print immediately. Some printers have a slot to plug in the storage card. If the printer has an LCD display, you can use that to choose which pictures to print. In either case, this method allows you to make prints without a computer.

Printing services

As convenient as it is to print your shots yourself, if you've got 60 of them to print, sitting in front of a computer for a few hours after you get home will feel like a chore; you'll probably want to use a printing service. Fortunately, lots of companies stand ready to do all that printing for you. You have three good options for having your prints processed by professionals:

∗ Camera shops and photo finishers accept storage cards or even floppy disks and CDs for printing. To have prints made, review your photos in the camera's display and note which ones you want printed. When you drop off the card, indicate which shots you want to make into prints. If you are creating a CD or floppy disk, copy only the files you want printed.

∗ Dozens of services let you upload your digital photos and order prints, which are then delivered directly to you. Although not all online services are the same, most have similar elements. Once you've uploaded pictures to a service, you can often store them at the service, post them in an album or on a Web page, and get standard 4-by-6-inch prints. Some also provide photo editing software or project

templates, customized photo albums, and tips for taking good pictures (**Figure 7.4**).

✳ You may noticed self-serve kiosks in your local drugstore or retailer. You can bring in your storage card, floppy disk, or CD, plug it into the kiosk, review the shots on the monitor, choose the print size, and get immediate gratification. Some kiosks allow you to make simple corrections like red-eye reduction and cropping before printing.

Figure 7.4 This online photo service offers many options for printing pictures, and gives you a large storage space for your photos so you, your friends, and family can view them easily.

Digital Camera Troubleshooting

Even the best digital cameras can give you problems sometimes. If you can't figure out what's wrong, your first stop should be your camera's manual. Many times the source of a problem is as simple as weak batteries or a mis-set option. In rare cases, there may be something wrong with the camera that requires a professional repair job. What follows are some typical problems and the best ways to approach solving them.

Camera won't turn on

You will run into this problem remarkably often. Fortunately, the answer is nearly always to replace the batteries, which are probably weak.

If you think the batteries are OK and the camera still won't turn on, make sure that the batteries are inserted correctly, with the proper position of the + and - ends. It is also possible that even a brand new battery is bad. Try a different set of batteries just to make sure.

If you own a camera with a lithium ion battery, place it in its battery charger and see whether the charger indicates that the battery is drained.

Check that the battery slot is firmly closed. If the battery can't make contact with the electronics inside, it can't work.

If you're shooting outdoors in the winter, your battery may be too cold. If so, warming it inside your glove for a few minutes should bring it up to usable temperature.

Camera won't take a picture

Check that there is enough room on the storage card to take more pictures. If not, either swap out the card or delete some shots to make room.

Some cameras will not take a picture if there isn't enough light and the flash is not ready. Look at the LEDs on the back of the camera. If any are flashing, that may mean that the camera doesn't like something about your shot. Check the manual to see what the lights mean.

If you have a clamshell camera (where the front of the camera slides over the retracted lens), make sure that the slide is pulled all the way. On some models, pulling the slide halfway puts the camera in Playback mode, which allows you to view but not take pictures.

Flash won't fire

In many cameras, the flash won't fire in certain modes. Try changing mode and shoot a test picture.

Check the camera's flash setting to see if it is in No Flash mode.

Some camera flashes need time to recharge, especially if you've just taken several shots in a row. Give the camera a few seconds for recharging.

Pictures are consistently under or overexposed

Some cameras retain exposure or flash compensation settings even after you turn the camera off and on again. Check these settings. It is easy to accidentally hit a button on the back of the camera that changes settings.

If the shot is underexposed, what you are trying to shoot may be out of flash range. Try to get closer and shoot again. If you can't get closer, adjust the exposure compensation to get a brighter shot.

Pictures are consistently out of focus

The most common reason for this problem is that the camera is set on Macro Focus. Check the display to see what the setting is and correct it if necessary.

Your lens may be dirty. Clean the lens with lens cleaner and a lens tissue.

Pictures have small distortions when enlarged

Because most digital cameras have small lenses, even a tiny fingerprint or dirt speck can loom large in a photo. Make sure that the lens is clean and dust-free. Never clean a lens with anything other than lens tissue. Paper towels and even tissues can easily scratch the lens.

Storage card can't be read

This is a common problem in cameras that use SmartMedia cards. Because the contacts on SmartMedia cards are exposed, they can get fingerprints or other shmutz that will prevent the camera from reading the card. Gently rub the contacts with a rubber pencil eraser. This will usually get the card up and running.

Sometimes, a storage card gets corrupted and needs to be reformatted. Check your camera's instructions for formatting cards. Keep in mind that reformatting a card wipes out any stored pictures.

When all else fails

If none of the suggestions above rectify the problem, you may have to have the camera serviced. This nearly always requires you to return the camera to the manu-facturer. Check with the company for instructions on where and how to ship your camera for service. Never send a camera without shipping instructions and always insure the shipment.

Index

127